IMAGES
of America

NASSAU VETERANS MEMORIAL COLISEUM

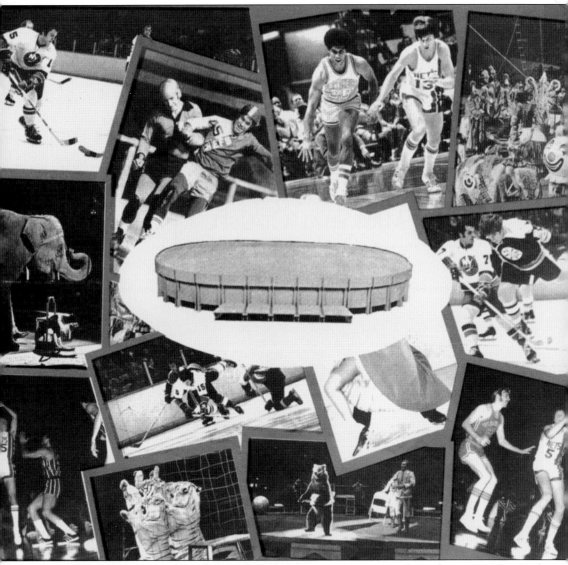

A 1970s ticket request form depicts the coliseum centering scenes from the circus, New York Chiefs roller derby, and Islanders and Nets games. Islanders winger Billy Harris, selected with the first pick in the 1972 amateur draft, is seen skating in the upper left-hand corner and tumbling to the ice in an image to the lower left of the arena. (Courtesy of Lance Elder.)

ON THE COVER: The Islanders' Oleg Kvasha chases the puck during a game versus the Montreal Canadiens on November 29, 2001. Kvasha's teammate, Mark Parrish, follows the play as Canadiens goaltender Jose Theodore scurries back to his net. The teams skated to a 1-1 tie in an era before deadlocked games went to shoot-outs to determine a winner. (Photograph by Jamie Squire; courtesy of Getty Images, Sport Collection.)

IMAGES
of America

NASSAU VETERANS MEMORIAL COLISEUM

Nicholas Hirshon
Foreword by Lance W. Elder

ARCADIA
PUBLISHING

Published by Arcadia Publishing
Charleston SC, Chicago IL, Portsmouth NH, San Francisco CA

Printed in the United States of America

Library of Congress Control Number: 2010922708

For all general information contact Arcadia Publishing at:
Telephone 843-853-2070
Fax 843-853-0044
E-mail sales@arcadiapublishing.com
For customer service and orders:
Toll-Free 1-888-313-2665

Visit us on the Internet at www.arcadiapublishing.com

To the courageous men and women who have
fought to give us a peaceful tomorrow

CONTENTS

FOREWORD

I still remember the smell of damp concrete at the coliseum. I was just 24 in January 1972 and had traded a workaday post within Nassau County government for an intriguing project. As Long Island awaited its new palace, I joined a crew ensuring that construction wrapped up promptly and smoothly. I marveled at the modern offices, major league locker rooms, and vast open space of the arena. The place blew me away.

I expected a temporary assignment there, but circumstances changed. Though the structure was not yet ready, the county scheduled a Nets basketball game for February 11. Hurried preparations required more workers than originally thought, so I stuck around. I oversaw the setup of the management offices and deliveries of the scoreboard, backboards, and basketball court. Eventually a superior asked if I wanted to become chief usher. I had never been an usher in a movie theater let alone an arena. Nevertheless, I accepted.

I acted as a sponge early on, absorbing wisdom from the coliseum's forthright general manager, Earl Duryea. Still a single statement almost cost me my job. Days before the Nets' debut, a *Newsday* reporter sat in on my preliminary talk to the ushers—without my knowledge. I warned my staff to be careful in the unfinished arena. Extremely low railings and incomplete seating sections created the risk of a 20-foot drop to the floor. Officials from Mineola to Albany called to reprimand me for a remark that might raise concerns about the venue's safety. I feared I might be fired, but my concerns were justified and I survived the bump.

I am grateful I stayed, because I loved the coliseum. I went on to serve two stints there, from 1972 through 1980 and again from 1988 through 1998, eventually rising to the role of general manager. I left more than a decade ago, but I still refer to it as "my building." I also bristle when I hear jokes about her outdated state. Sure the old lady needs upgrading. But consider her extraordinary history. With age comes a terrific tale to tell.

—Lance W. Elder
East Norwich, New York

ACKNOWLEDGMENTS

As with any project of this scope, the author cannot claim sole credit for the finished product. I relied on many sources to illuminate the coliseum's oft-overlooked legacy in sports, music, and beyond. I owe my greatest debt to Lance Elder, the arena's former general manager, whose expertise proved invaluable to my research. His affability and humor served as constant encouragement, and his foreword lends a first-hand historical narrative to this book.

The coliseum's history comes alive in these pages through photographs by Joseph T. Farriella, Joseph O'Rourke, Jackson B. Pokress, and Rich Walker. I discovered many more with assistance from Tim Beach, Marisa Berman, Bill Crockett, Laura Davis, Simon Elliott, Doug Fritts, Robert L. Harrison, Michael Katz, Michael Lipack, Thomas Rakoczy, Stu Saks, Mary Ann Skinner, and Angela Troisi. A special tribute goes to Frank Vitucci of World Wrestling Entertainment, Inc., for his organization's generosity.

I scoured records with aid from Julia Blum, Andrew Parton, and Joshua Stoff at the Cradle of Aviation Museum in Garden City, George Fisher at the Nassau County Photograph Archives Center in Old Bethpage, and Geri Solomon at Hofstra University in Hempstead. I benefited particularly from reports in the *Long Island Press*, *New York Daily News*, *New York Times*, and *Newsday*.

I must also thank my family and friends. In my childhood, my mother secured tickets for my first Islanders game at the coliseum—no points deducted for picking a 5-0 thrashing by the Calgary Flames. My father drove me to many more events there. My pal and fellow author, Jason D. Antos, urged me to pitch this book, while my Arcadia editor, Rebekah Mower, skillfully guided me to publication.

My title intentionally shuns the venue's abbreviation as "Nassau Coliseum," for the two words excluded in that form carry too much significance. The county named the arena after veterans whose sacrifices must never be forgotten.

Lastly I strove to pack as much of the coliseum's history as possible into this volume, but I hope my readers will forgive omissions due to space constraints. Please focus, instead, on a venue that is well worth cherishing.

INTRODUCTION

Moments before the face-off, Bob Nystrom pulled his hand from its blue-and-orange glove and scratched his cheek. It was overtime on Long Island, and Nystrom itched with the sweat of a fierce series. His New York Islanders, mocked as chokers after several failed play-off runs, now needed just one goal to win the Stanley Cup. The home club lined up opposite the Philadelphia Flyers while the faithful roared at Nassau Veterans Memorial Coliseum.

Philadelphia, in its defensive zone, corralled the puck off the draw. Then an errant pass through center ice found an Islanders stick. Fans pulsed with anticipation. In sudden death, as both sides knew, a seemingly harmless possession could swiftly develop into a score and a triumph. So Islanders centerman Lorne Henning hoped as he guided a neutral-zone feed to John Tonelli. Crowd noise jumped an octave.

Racing over the blue line, Tonelli pushed the puck to Nystrom. Blade met rubber disc. Not every spectator saw the black speck cross the goal line, but they certainly realized. Nystrom's weary arms shot in the air. Henning hugged him first, then Tonelli, then the rest of the new champions of hockey.

On May 24, 1980, Long Island had arrived.

The moment that rocked the region was decades in the making. The Islanders would have never existed, after all, had the spot of their arena remained runways on the Hempstead Plains. That transition began on April 15, 1961, when the U.S. Air Force ceased operations at its Mitchel Field base. Since emerging as a center for aviation training during World War I, the sprawling complex had often witnessed history. Global speed records were set there in 1920 and 1925. Charles Lindbergh departed on a national tour in the *Spirit of St. Louis* in 1927. Pilots in Adm. Richard Byrd's first Antarctic expedition chose the site to test their planes in 1928. Throughout World War II, Mitchel Field's thousands of officers assumed aerial responsibility for the entire northeastern United States.

That legacy, however, mattered less by the 1950s. Mitchel Field, which had been constructed in a relatively uninhabited swath of Nassau County, now stood surrounded by suburban communities. The neighbors in East Meadow, Hempstead, and Levittown endured aircraft accidents in 1955, leading to deaths and damaged property. Some complained about jet noise. Others worried the base might be a target in war, endangering residents nearby. Robert Moses, the powerful president of the Long Island State Park Commission, urged the air force to relocate.

Amid mounting pressure, the U.S. Department of Defense announced plans in 1960 to close the 1,168-acre installation. The air force identified its motive as a shift from manned flights to missiles, dooming Mitchel Field as well as bases in Florida and Louisiana. Critics on Long Island rallied and signed petitions, fearing the loss of jobs and local government spending. But the decision stood, and attention turned to the land's future.

Debates about its destiny proved messy. The air force, after offering the site as per procedure to the army and navy, handed it to the General Services Administration for disposal. Expecting a

sale, Nassau County executive A. Holly Patterson organized an 11-member committee, including Moses, to decide Mitchel Field's fate. Proposals followed in summer 1961 within and beyond the panel. Two divergent factions appeared: the Federal Aviation Agency in support of an airport and Patterson and Moses against. Backed by local business executives, the FAA pitched a field for single-engine and small twin-engine planes to ease burdens on metropolitan-area airports. Patterson's committee preferred education, recreation, and light industry on the property.

A stalemate ensued. Rules required Mitchel Field to be tendered first to federal agencies, so the county could not purchase it until the FAA dropped its bid. The FAA, meanwhile, could not find a regional sponsor for the airport in the wake of county opposition. Disputes grew fierce. The area's major daily newspapers, the *Long Island Press* and *Newsday*, vehemently assailed the airport plans on their editorial pages. Then, on August 1, 1961, the U.S. House of Representatives voted to bar the FAA from spending in the county without the local government's approval. A *Press* cartoon triumphantly depicted an arm, labeled FAA, restrained from ramming the airport down Long Island's throat. Patterson and Moses had scored a tide-turning victory.

The FAA maintained its resolve even though its cause seemed increasingly lost. The U.S. Senate refused the House of Representatives measure but approved an amendment requiring the FAA to give "fair consideration" to the community's wishes. Public hearings on Long Island in January 1962 affirmed that the FAA's opponents outnumbered its supporters. The controversy finally died on February 27, when newly elected county executive Eugene Nickerson announced the FAA had abandoned its proposal. All that remained was to divvy up Mitchel Field.

Distribution of the parcel proceeded largely as Patterson's committee had hoped. In May 1962, the General Services Administration divided nearly 250 acres among Hofstra College (soon to become a university), Nassau Community College, and public schools. The government initially reserved another 313 acres for federal buildings. A year later, in 1963, Nassau County bought 435 acres for $13.6 million. The transaction yielded plans for a seven-building cultural center named after the late president John F. Kennedy. At the core of the project was an enclosed coliseum, envisioned as the premier sports venue on Long Island.

Ballooning costs led county officials to scrap all structures but the arena in 1968. The architects chosen for the venture, Welton Becket and Associates, conceived a concrete-and-stone structure with an exhibition hall for trade shows and between 12,000 and 17,000 seats for events. Construction on the $28-million arena began in 1969, as did buzz about potential tenants. New county executive Ralph Caso decided Nassau should negotiate its own contracts for activities rather than hire an operator. To secure big-league teams, Caso relied on consultant William Shea, who had been widely credited with bringing the Mets baseball club to New York City. Shea did not disappoint. First he booked the New York Nets of the American Basketball Association, a franchise eager to break a chain of subpar home courts. Next he convinced the National Hockey League to award an expansion team. Rumors also swirled about boxing, concerts, ice shows, rodeos, and roller derbies.

Expectation swelled in early 1972 when crews neared completion on Nassau Veterans Memorial Coliseum. Media reports of its state-of-the-art lighting, modern sound system, and unobstructed sight lines generated more excitement. Earl Duryea, the coliseum's first general manager, predicted his arena would end Madison Square Garden's undisputed stranglehold in the vicinity. "Now there are two shows in town," he boasted to *Newsday*.

Locals still awaited a glimpse, and the county ultimately obliged. Around 8:15 p.m. on February 11, 1972, the coliseum debuted with a Nets tip-off against the Pittsburgh Condors. Venue officials had estimated only 7,000 seats would be available, but last-minute arrangements allowed a crowd of 7,892. New York beat Pittsburgh, 129-121, marking the first time in four tries the club won its inaugural game in a new home.

Long Island, too, earned a fresh start at the coliseum. Caso predicted the arena would provide an identity the region sorely lacked. Indeed the nation would soon regard the county and its coliseum as home to champions.

One

UNVEILING A STONE HATBOX

Before the coliseum granted identity to Long Island, its design jolted the media's collective imagination. Some journalists compared the oval arena to a hatbox. To others, it resembled a sand castle or a saucer. A handful, perhaps craving the venue's concessions, likened it to a giant mushroom, a loaf of bread, or a huge vanilla cake.

Most crucially for the New York Nets, few reporters drew analogies to the franchise's last home. In the pre-coliseum era, the Island Garden in West Hempstead had reigned almost by default as the region's prime option for indoor entertainment. It lured droves to Hempstead Turnpike for circuses, concerts, and Nets games, much like the coliseum hoped to do just 4 miles away along the very same stretch. But the similarities ended there. The Island Garden's capacity peaked around 6,000. Rain leaked onto the court. Nets guard Bill Melchionni, after the team's 1972 switch to the coliseum, described the move as "going from the outhouse to a bathroom with plumbing."

The inaugural crowd, though treated to a Nets victory in the February 11 opener, seemed more enamored with the new arena than Rick Barry's 45-point night. Fans had waited nearly a decade for the coliseum experience, and they relished it. After driving into the horseshoe-shaped, 6,000-car lot, some paid $2 for spaces just a few hundred yards from the closest entrance. Others opted for $1 spots, none more than a quarter-mile from the venue. Armed with tickets priced between $5.50 and $7.50, throngs then strolled through one of 67 pairs of doors. They proceeded to sections marked with chalk numbers, and settled into seats ranging in width from 19 to 22 inches.

No debut, however, would be complete without a few disappointments. The four stands on the concourse level, run by concessionaire Harry M. Stevens Inc., offered mostly snack food, forced to forgo a full menu because the county reportedly delayed clearing its equipment. Spectators griped that sound from the speakers was too loud and garbled. A woman arrived with a trio of children in Section 317, only to find their seats had not yet been installed.

Such glitches, however, faded to the background. For most, the site's transition from abandoned airstrips to gleaming arena left the greatest impression.

The Mitchel Field base was named after John Purroy Mitchel, the youngest mayor in New York City history upon his inauguration at age 34 in 1914. Though credited with reforming city hall, he lost re-election in 1917 and joined the air service. On July 6, 1918, Mitchel died when he dropped 500 feet from a single-seater plane while training in Louisiana. (Courtesy of Cradle of Aviation Museum, Garden City, New York.)

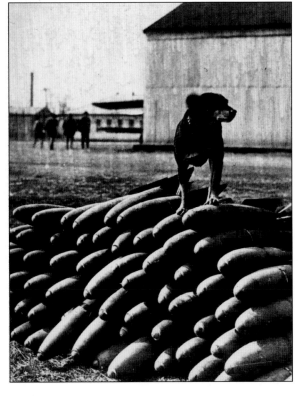

A dog stands atop a bomb pile at Mitchel Field around 1920. Following World War I, the base welcomed numerous aviation pioneers. On September 8, 1924, three pilots touched down near the end of the first successful flight around the world. A crowd of 5,000, including the Prince of Wales, cheered the arrivals of Erik Nelson, Lowell Smith, and Leigh Wade. (Courtesy of Cradle of Aviation Museum, Garden City, New York.)

Proving that aviation technology could conquer fog and darkness, Lt. James Doolittle completed the first "blind" flight at Mitchel Field on September 24, 1929. Doolittle climbed into the rear cockpit of a Consolidated NY-2 biplane and flew beneath a canvas hood that prevented him from seeing where he was going. Rather than relying on visual landmarks, Doolittle trusted his navigational instruments. A second pilot, Benjamin Kelsey, sat at the front controls for safety purposes but did not intervene. At the conclusion of a 15-mile course, Doolittle landed near the spot where he had taken off minutes earlier. Experts hailed the revolutionary step toward achieving air travel in murky conditions. Decades later, Doolittle was honored with the naming of a boulevard in front of the Long Island Marriott in Uniondale, just steps from the coliseum. (Courtesy of Cradle of Aviation Museum, Garden City, New York.)

Douglas O-38 observation biplanes rest in a row at Mitchel Field. During the aircraft's rise to prominence in the 1930s, Mitchel Field flexed its growing aerial muscle. In an exercise on May 12, 1938, a trio of B-17 bombers flew 750 miles to sea to "intercept" the Italian ocean liner *Rex*. The demonstration, though planned, asserted the feasibility of long-range reconnaissance. (Courtesy of Cradle of Aviation Museum, Garden City, New York.)

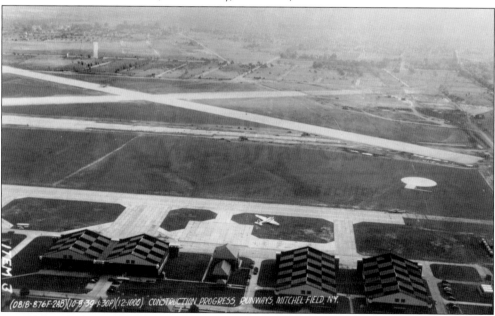

A 1939 aerial photograph shows the runways and checkerboard hangars of Mitchel Field. The same year, Benjamin Kelsey, who had accompanied James Doolittle on the first-ever blind flight, set a record for the speediest transcontinental trip. He made two stops while traveling from California to Mitchel Field in 7 hours, 45 minutes. Kelsey crashed at the conclusion and suffered minor injuries. (Courtesy of Cradle of Aviation Museum, Garden City, New York.)

Mitchel Field served as a crucial cog in the nation's air defenses during World War II. In 1940, before the United States had even entered the conflict, Pres. Franklin D. Roosevelt authorized the shipment of 55 bombers from the Long Island base to Nova Scotia in Canada. The gesture marked the first delivery of warplanes from American to British territory. (Courtesy of Cradle of Aviation Museum, Garden City, New York.)

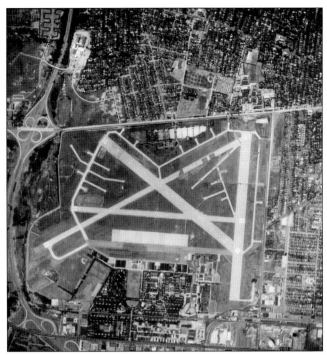

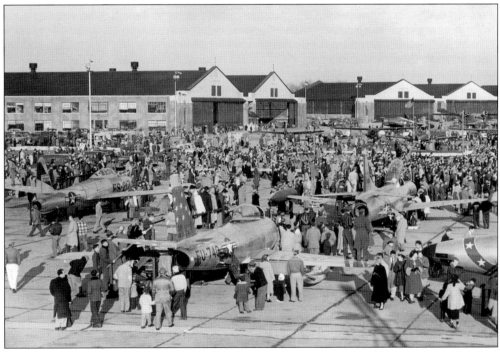

Visitors roam a maze of planes during a Mitchel Field open house in 1954. Often scheduled to celebrate military anniversaries, tours of the base in the 1940s incorporated flyovers by the likes of P-51 Mustang fighters. The displays turned static by 1950, however, as burgeoning communities around Mitchel Field rendered air shows too risky. (Courtesy of Cradle of Aviation Museum, Garden City, New York.)

Aerial photographs record the same spot in 1966 (above), shortly after the Mitchel Field base shuttered, and 2006 (below), when the coliseum celebrated its 34th anniversary. The runways and flat grassland on this portion of the airfield became Nassau County property as part of a 435-acre, $13.6-million deal with the federal government in June 1963. Plans originally called for educational and technical uses as well as a cultural center. The next year, architects submitted plans for a 900-by-900-foot "pedestrian podium," or raised foundation. They proposed six buildings there: an art gallery, concert hall, library, social center, theater, and a museum of history, industry, science, and transportation. A sunken garden was pitched to separate the podium from a 10,000-seat coliseum. Only the arena came to fruition. (Courtesy of HistoricAerials.com.)

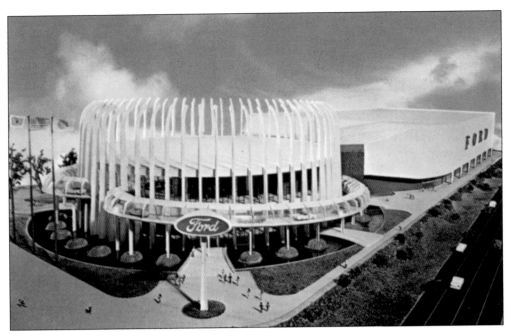

Nassau County leaders directed Welton Becket and Associates, one of the nation's largest architectural concerns, to design the coliseum. At the time, the firm boasted pavilions for the Ford Motor Company (as seen on the postcard above) and General Electric (below) at the 1964–1965 World's Fair in Queens. The Ford exhibit dazzled with 100-foot-high pylons surrounding a glass rotunda, while General Electric's display awed beneath a steel, pipe-supported dome. Becket had also envisioned the Los Angeles Memorial Sports Arena, then home to the Lakers of the National Basketball Association. At Mitchel Field, he conceived a venue with terrific sight lines. Becket died in 1969, three years before the coliseum opened. (Courtesy of the Queens Historical Society.)

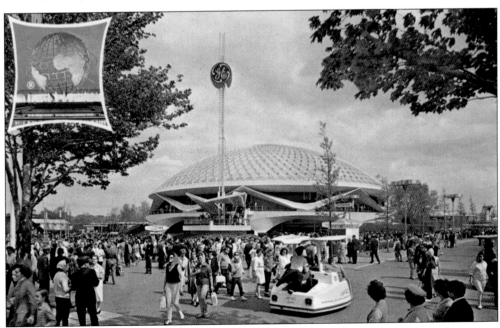

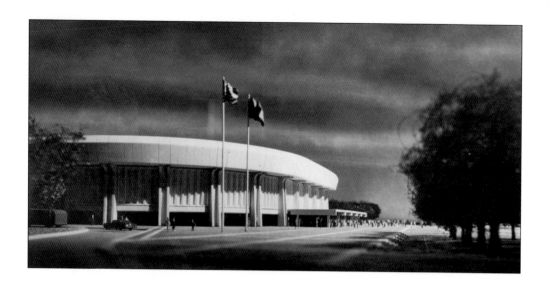

Early models for the coliseum display the oval shape and concrete columns that would become familiar to generations of Long Islanders. Pictured above, visitors stroll past trees and flagpoles to enter the rectangular lobby, much as real-life fans would in decades to come. Other elements seen here, however, were never implemented. For example, these mock-ups portray strips protruding between the columns and sloping panels lining the top of the venue. In contrast, the actual coliseum excluded the strips and employed flat panels separated by grooves. These miniatures also feature steps and fountains outside the arena, whereas the coliseum's landscaped plaza did not. (Courtesy of Lance Elder.)

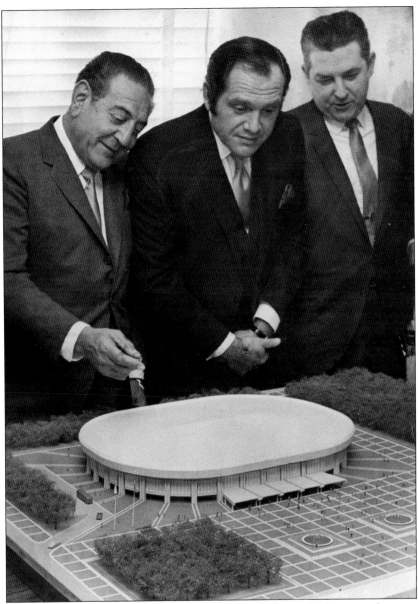

Bandleader Guy Lombardo (left) and comedian Alan King (center) admire a coliseum model in January 1969. Lombardo, who lived in Freeport, and King, who resided in Great Neck, served as directors of the Nassau Coliseum Corporation, which oversaw the venue's development. In the late 1960s, plans for the arena stalled amid disputes between the Democratic county executive, Eugene Nickerson, and the Republican supervisors of Hempstead. Seeking to remove political pressure, the county formed a quasi-public corporation to build the coliseum. Shortly after, Nickerson's first deputy, Daniel Sweeney (right), announced he would relinquish his post to become company president. But the corporation did not last long. Nickerson's successor, Republican Ralph Caso, asked the board to disband shortly after his election in 1970. He instead passed the coliseum plans to the county Department of Commerce and Industry. The grid-like design of the plaza, as suggested in this model, gave way to nondescript concrete in subsequent mock-ups. (Photograph by Jim Nightingale; courtesy of *Newsday* LLC.)

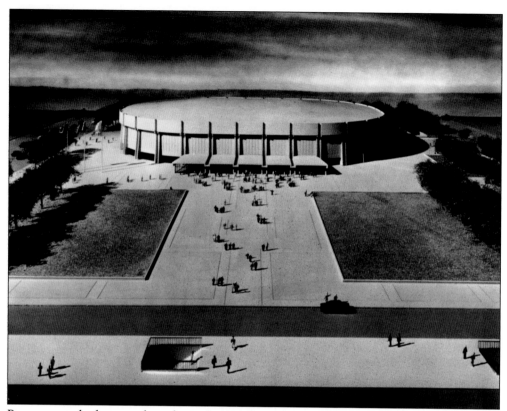

Patrons cast shadows on the coliseum's reconfigured plaza in this model. Two grassy patches sandwich a square-centered concrete approach, replacing the fountains and grid layout that marked previous miniatures. The plans changed again, though, including the addition of four-pronged lampposts to illuminate the walkways at night. (Courtesy of AECOM Ellerbe Becket and UCLA Library, Elliot Mittler Collection.)

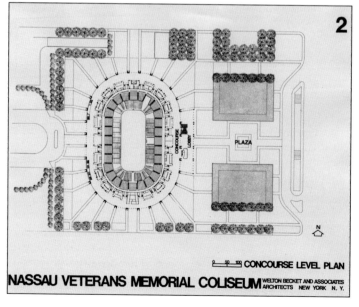

This blueprint shows the coliseum's plaza, lobby, and concourse, as well as seats surrounding the arena floor. Architects designed the concourse to wrap around the entire two-level structure, promoting easy access to seats above and below. Still fans soon grumbled about navigating the narrow concourse, where crowds converged on concessions, restrooms, and exits. (Courtesy of AECOM Ellerbe Becket and UCLA Library, Elliot Mittler Collection.)

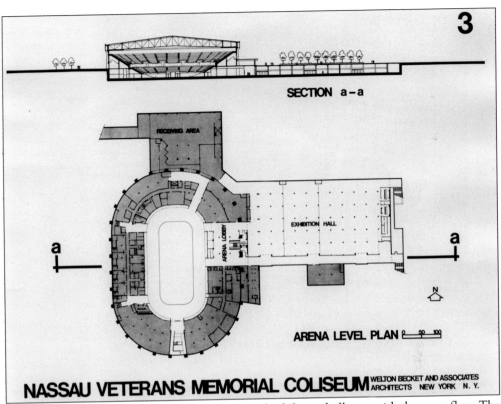

SECTION a–a

RECEIVING AREA

EXHIBITION HALL

ARENA LOBBY

ARENA LEVEL PLAN

N

NASSAU VETERANS MEMORIAL COLISEUM WELTON BECKET AND ASSOCIATES ARCHITECTS NEW YORK N.Y.

This architectural scheme proposes an underground exhibition hall even with the arena floor. The layout became reality with the coliseum rising approximately 75 feet above grade and boasting sunken space for arena seating and exhibition hall events. County officials estimated that the coliseum measured 460 feet at its longest point and 340 feet at its widest. (Courtesy of AECOM Ellerbe Becket and UCLA Library, Elliot Mittler Collection.)

Initial seating plans for ice hockey and stage shows convey the coliseum's two-tiered split. Early visitors with last-row tickets complained about the steep, 57-step climb without a handrail for support. But they relished unobstructed views from even the most remote seats, estimated to be 50 feet closer than the nosebleeds at Madison Square Garden. (Courtesy of AECOM Ellerbe Becket and UCLA Library, Elliot Mittler Collection.)

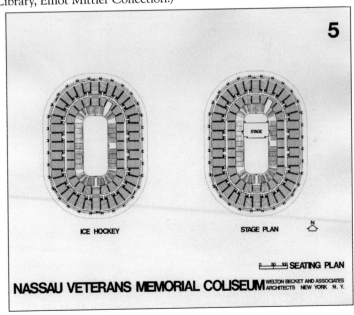

ICE HOCKEY

STAGE

STAGE PLAN

N

SEATING PLAN

NASSAU VETERANS MEMORIAL COLISEUM WELTON BECKET AND ASSOCIATES ARCHITECTS NEW YORK N.Y.

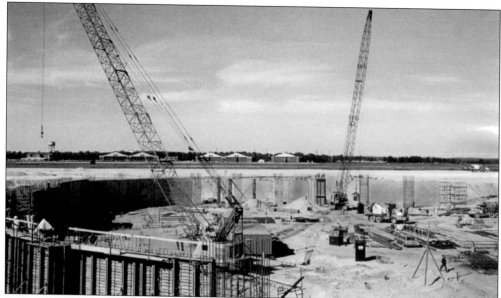

Cranes erect the coliseum in October 1969, while debates rage about plans for housing near the arena. Months earlier, the Mitchel Field Development Corporation suggested a dozen apartment buildings for about 5,000 residents. Supporters pointed to a housing shortage and argued that the complex workers should live at the site to avoid transportation problems. Nevertheless, the county's Republican leaders scrapped housing. (Photograph by Jim O'Rourke; courtesy of *Newsday* LLC.)

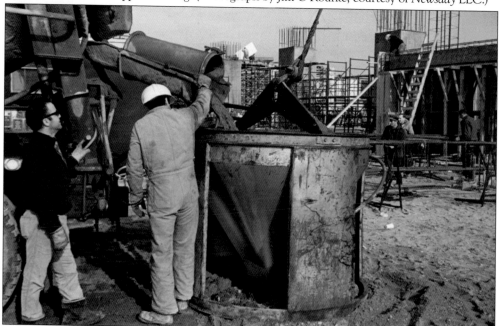

Concrete mix spills into a bucket at Mitchel Field in December 1969. Inspectors then checked the mix's temperature before a crane hoisted the bucket to the top of the coliseum's wall for pouring. The crews also cracked jokes about the coliseum's alternately spelled Roman counterpart. The *New York Times* reported that one worker posted a placard reading, "Lions vs. Christians (no charge)." (Photograph by Tom Maguire; courtesy of *Newsday* LLC.)

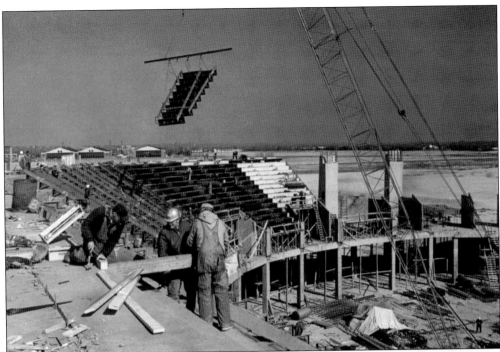

A crane moves a steel section into place as the coliseum's skeleton takes shape in February 1970. At the time, the arena factored as just one piece of an ambitious vision to transform Mitchel Field in five years or less. Other proposed structures included apartment and office buildings, a central reference library, a hotel, retail shops, and multilevel, underground parking garages. (Photograph by Tom Maguire; courtesy of *Newsday* LLC.)

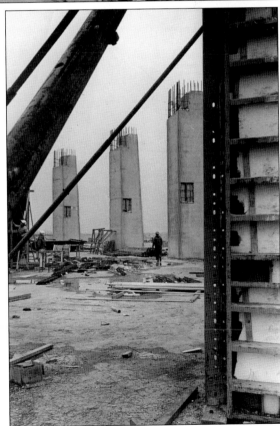

Named after a landmark from ancient Rome, the coliseum bears a closer resemblance to Stonehenge in this construction photograph from March 1970. Its designers enlisted 32 exterior columns, including several seen here, to support the roof. Inside the arena, spectators enjoyed excellent, pillar-free sight lines thanks to 10 steel trusses, each 323 feet long and 25 feet deep. (Photograph by Jim O'Rourke; courtesy of *Newsday* LLC.)

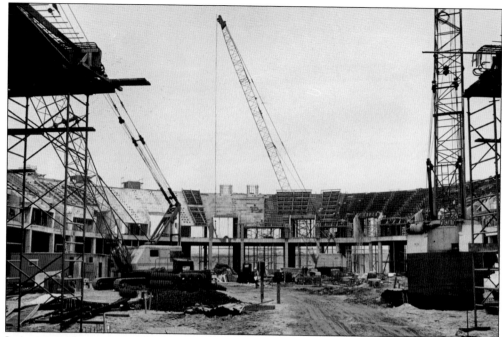

In its incomplete state in March 1970, the arena mirrors the Colosseum of ancient Rome. Many Mitchel Field workers embraced the comparison. According to the *New York Times*, one official adorned his wall with this famous line from a medieval historian: "While stands the Colosseum, Rome shall stand; when falls the Colosseum, Rome shall fall; and when Rome falls, the world." (Photograph by Jim O'Rourke; courtesy of *Newsday* LLC.)

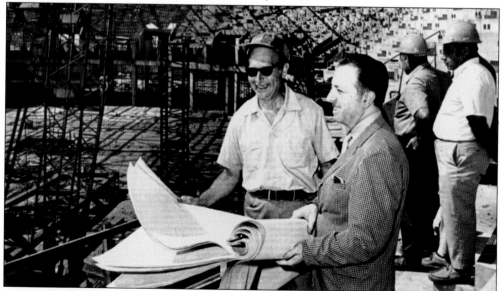

Ralph Caso (right), then vice chairman of the Nassau County Board of Supervisors, surveys blueprints in 1970 with the arena's construction manager, Irwin Schlef of Oceanside, Long Island. Caso, a Republican, later defeated Glen Cove mayor Andrew DiPaola, a Democrat, in the November election for county executive. Weeks after his victory, Caso announced a county-controlled approach to running the arena. (Courtesy of Hofstra University Special Collections.)

24

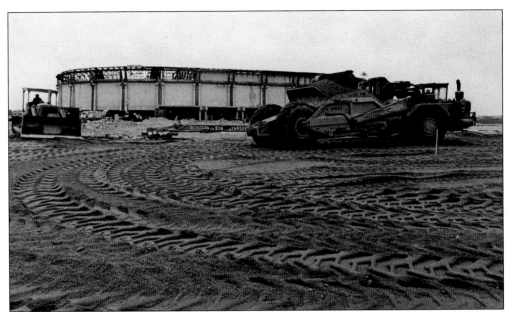

A road grader levels dirt by the partially completed coliseum in November 1970. Bulldozers covered this area with macadam in early 1972, creating convenient parking spaces near the lobby. With access from Oak Street, Hempstead Turnpike, and the Meadowbrook Parkway, the 6,000-car lot initially charged either $1 or $2, depending on the location of the spot. (Photograph by Ken Spencer; courtesy of *Newsday* LLC.)

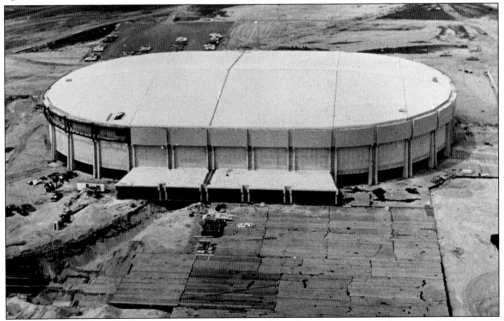

Work on the coliseum's exterior concludes as crews shift their attention to the plaza. Architecture critics knocked the bland facade of off-white concrete and split-face concrete stone, but they also commended the arena's interior attributes. Venue management employed closed-circuit television for security and a compactor that crushed garbage into 20 percent of its original volume. (Courtesy of the Nassau County Department of Parks, Recreation, and Museums, Photograph Archives Center.)

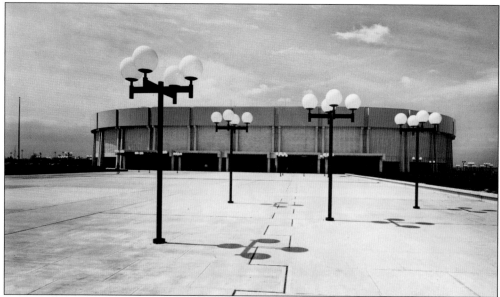

Lampposts dot the plaza in front of the finished coliseum. Long Island's new sports and entertainment center appeared much like models envisioned, though a tight budget forced planners to drop some components. Early designs called for four escalators leading from the lobby to the arena level and the exhibition hall, but only two were installed. (Courtesy of AECOM Ellerbe Becket and UCLA Library, Elliot Mittler Collection.)

New York Nets and Islanders owner Roy Boe (right) poses for a photograph with Nassau County executive Ralph Caso inside the recently completed coliseum on February 9, 1972. The fashion entrepreneur's stewardship encompassed Nets championships in 1974 and 1976 and the Islanders' steady rise from neophytes to contenders. Saddled with debt, Boe sold both franchises in 1978. (Courtesy of AP/Wide World Photographs.)

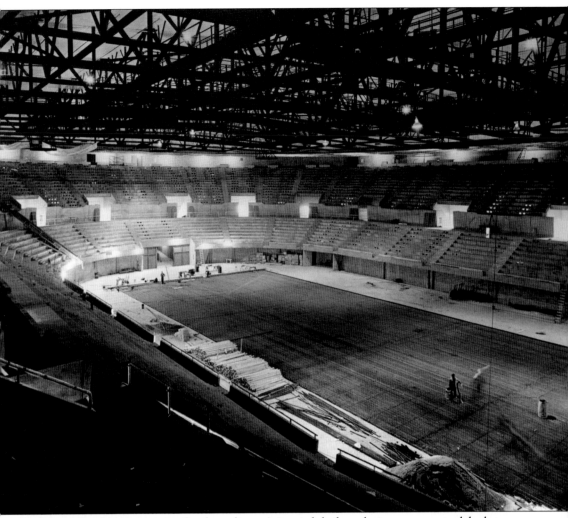

Crews install refrigerant piping for the coliseum's ice rink before placing a concrete slab above. The ice-making process lasted about 24 hours. First nearly 20 miles of steel pipes froze the floor. Hoses then poured water onto the surface. After a layer of ice formed, workers sprayed a paint-like white powder to make the ice visible. More water coated the chilly slab to ready it for skating. If non-ice events required the arena floor, the coliseum staff did not need to melt the surface. Instead they saved time and money by covering it with a nine-layer, insulated floor of wood and hardened foam. Conversions from basketball to hockey became routine. Employees unbolted 210 sections of court, each measuring 4 by 8 feet. They then removed the insulated floor to reveal ice underneath. (Courtesy of AECOM Ellerbe Becket and UCLA Library, Elliot Mittler Collection.)

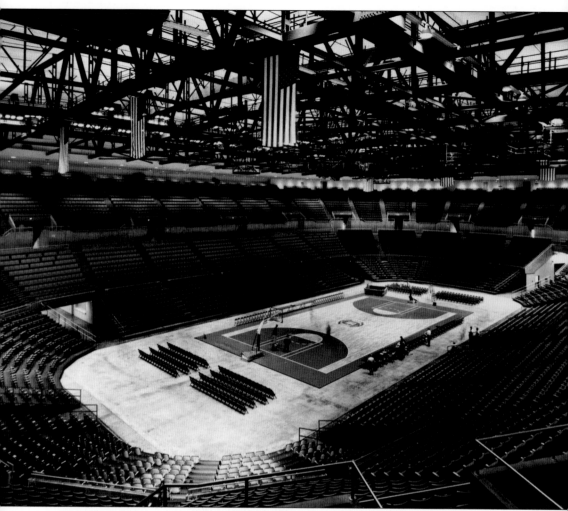

A scoreboard from the Nets' previous home, the Island Garden in West Hempstead, hovers above the coliseum basketball court in 1972. The team also transported the Garden's floor and backboards after being told new equipment would not arrive in Uniondale until the next season. Additionally this picture shows the ceiling's network of black girders supporting American flags and spotlights. *Newsday* reported the coliseum's electrically powered systems for lighting, sound, and other uses required five million watts, or enough to supply 250 private homes. But the mechanisms flopped at the Nets' first coliseum game on February 11. Photographers scurried along the court because lighting quality varied throughout the venue. The speakers, meanwhile, boomed too loudly for spectators in the lower level. Once they were turned down, fans in higher seats protested. (Courtesy of AECOM Ellerbe Becket and UCLA Library, Elliot Mittler Collection.)

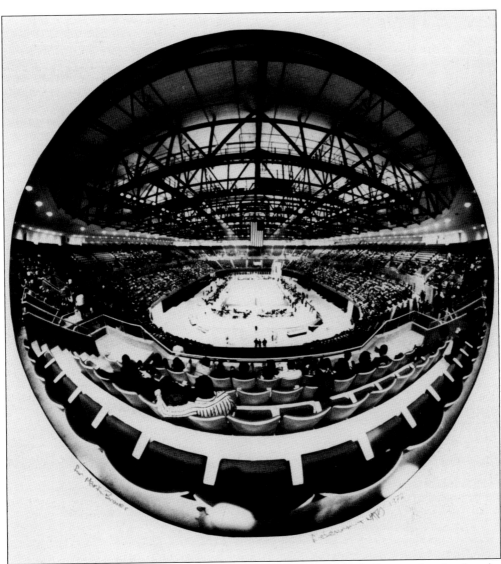

Scattered crowds in upholstered, theater-type seats follow a basketball game shortly after the coliseum opened. A 1972 advertisement guaranteed a "stimulating indoor climate and a year-round temperature of 75 degrees," as well as unobstructed views of the arena floor. Only half of the expected 15,500 seats, however, were installed in time for the Nets' February 11 opener. Fans at the inaugural game also noted the improper display of an American flag hanging from the rafters. Reversing protocol, the flag's field of stars faced west instead of east. Team officials vowed to correct the error before the next home contest on February 16. Matched against the Utah Stars, the Nets lost 119-114 despite a 50-point effort by small forward Rick Barry. He also notched 13 rebounds and seven assists. (Courtesy of AECOM Ellerbe Becket and UCLA Library, Elliot Mittler Collection.)

The coliseum rink assumes a whimsical aura during its first-ever engagement, the Shipstads and Johnson Ice Follies from April 12 to 23, 1972. Olympic gold medalist Peggy Fleming headlined the revue alongside cartoon beagle Snoopy, seen below in an advertisement with a coliseum drawing. Tickets ranged between $4 and $8 for what served as the arena's official opening. County executive Ralph Caso arrived by limousine and addressed the crowd of about 10,000 before the spectacular began. In keeping with the theme "Everything is Beautiful," skaters donned attractive attire as they leaped and twirled. Besides Fleming and Snoopy, the extravaganza featured Richard Dwyer, billed as "Mr. Debonair," and his partner Susan Berens. After the 2.5-hour show, politicians celebrated at a reception with champagne, beef, and melon balls. (Above, courtesy of Lance Elder; below, courtesy of PEANUTS © United Feature Syndicate, Inc.)

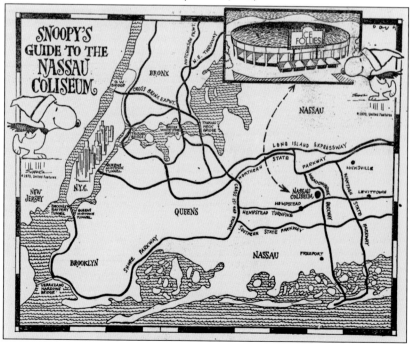

Delayed until Memorial Day 1972, the coliseum's dedication ceremony gave prominent roles to military and veterans groups. John Ray, the director of the Nassau County Veterans Service Agency, acted as the master of ceremonies, and the national anthem was sung by the band from the U.S. Merchant Marine Academy at Kings Point. This patriotic program appeared in red, white, and blue, while an eagle-topped plaque cited "courageous men and women who have fought to give us a peaceful tomorrow." Speakers included Fred Rhodes, the deputy administrator of the U.S. Veterans Administration, and county executive Ralph Caso. Performing the benediction was the Rev. Walter Kellenberg, bishop of the Diocese of Rockville Centre. (Right, courtesy of Lance Elder; below, photograph by the author.)

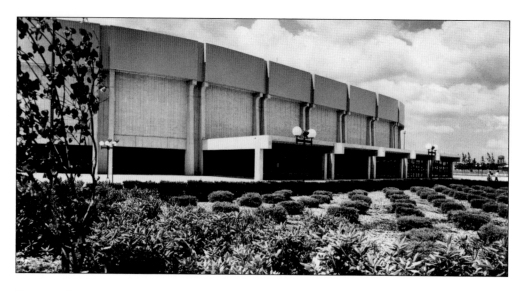

Photographs taken from similar angles document how the coliseum facade appeared in the early 1970s and on a snowy day in 2010. While the basic design did not change much through the decades, several key differences are visible. Most noticeably, once-bare panels above the lobby now don advertisements next to the coliseum's name and logo. One section boasts the venue is "Home of the N.Y. Islanders," and another heralds the Lighthouse at Long Island, a proposal to renovate the coliseum and redevelop acres around the arena. Also the previously unadorned grooves on the columns now sport triangles, while an electronic sign plugs Monster Jam Freestyle Mania. (Above, courtesy of AECOM Ellerbe Becket and UCLA Library, Elliot Mittler Collection; below, photograph by the author.)

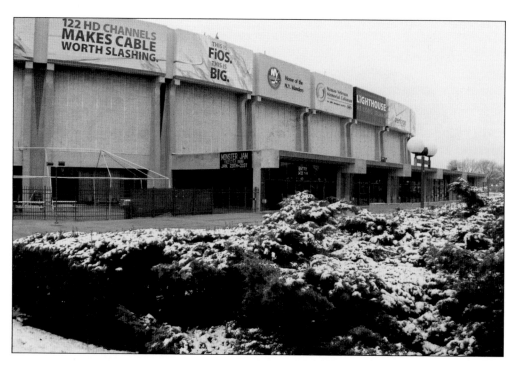

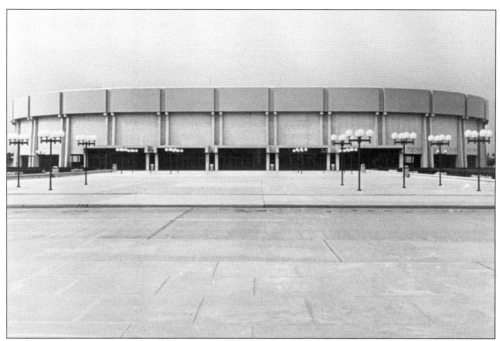

Views from the coliseum's parking lot show the arena and its landscaped plaza in the early 1970s and 2010. Besides aesthetic adjustments, the facility switched from public to private operators between the times these pictures were snapped. Months before the coliseum debuted, the county hired Earl Duryea as the venue's first general manager, agreeing to a three-year, $105,000 contract. Duryea previously ran the Salt Palace in Salt Lake City, a sports and convention complex that housed the Utah Stars of the American Basketball Association. County officials now rely on a Philadelphia-based company, SMG, to manage the coliseum. The photograph below displays the SMG logo on the center panel of the facade. (Above, courtesy of the Nassau County Department of Parks, Recreation, and Museums, Photograph Archives Center; below, photograph by the author.)

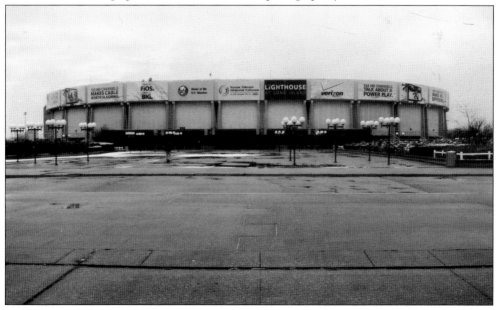

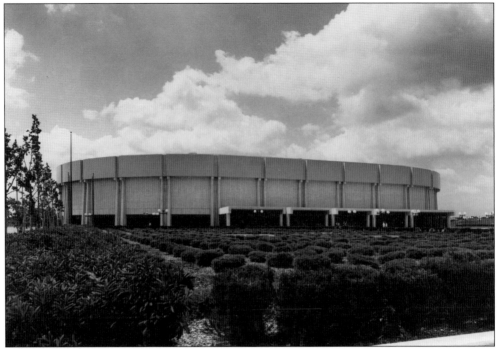

Clouds drift over the coliseum in the early 1970s. To offer shows at Long Island's state-of-the-art arena, promoters paid at least $8,333 a night or 17.5 percent of gross ticket sales, according to *Newsday*. An initial promotional brochure trumpeted the venue's proximity to "the most affluent areas in this high-density" suburb. (Courtesy of AECOM Ellerbe Becket and UCLA Library, Elliot Mittler Collection.)

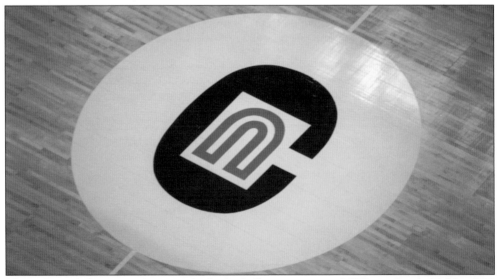

The coliseum's logo, seen here on the basketball court, set a red "N" inside a bold, blue "C." Venue officials exhausted the emblem in early marketing materials, which labeled the arena the "most modern" among competitors such as Madison Square Garden and the New York Coliseum. Pamphlets listed the venue's computerized ticket service, state-of-the-art dressing rooms, and 11 concession stands as advantages. (Courtesy of Rich Walker.)

On the coliseum's lower level, the exhibition hall opened in 1972 with nearly 62,000 square feet of floor space. Hoping to lure circus promoters and conventioneers, county officials advertised the hall's 20-foot ceilings, 2,104 fluorescent lights, and 2,647 electrical outlets. Exhibitors could drive into the display area, located near the arena floor, to unload their wares. An advertising supplement billed its promise to *Long Island Sunday Press* readers: "Where one day the bearded lady sat, on the next a businessman may see the latest in computerized inventory control systems or an avid fan of felines may view the best of that independent domestic species." Critics, however, harped on two main disadvantages. In a cost-cutting move, architect Welton Becket and Associates supported the ceiling with columns that severely limited exhibitors' space. Secondly the neighborhood lacked enough hotels to accommodate out-of-towners. The Long Island Marriott now offers more than 600 rooms opposite the coliseum, but visitors still gripe about the hall's cramped conditions. (Courtesy of Rich Walker.)

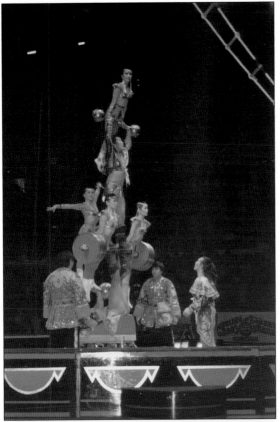

Ending a 16-year absence on Long Island, the "Greatest Show on Earth" encamped at the coliseum in fall 1972. Ringling Brothers and Barnum and Bailey had not brought the circus to the region since pitching a striped tent in Hicksville in 1956. The show then shifted exclusively to major indoor arenas, which Long Island lacked at the time. That changed with the coliseum. Irving Feld, the producer of the circus, told *Newsday* that Long Island was "no longer the backyard of New York, but an important and major market." The two-week run in Uniondale, starting October 31, featured lion tamer Pablo Noel and a trapeze act named the Flying Gaonas. Here Ringling Brothers and Barnum and Bailey continues its coliseum tradition with acrobats and elephants on March 18, 1992. (Courtesy of Rich Walker.)

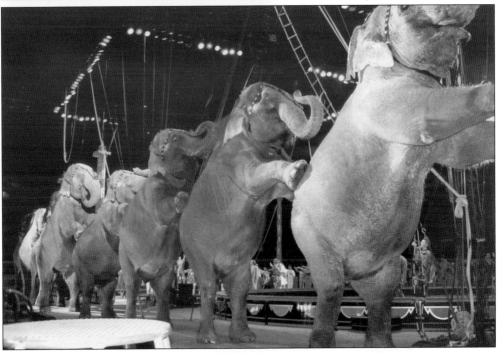

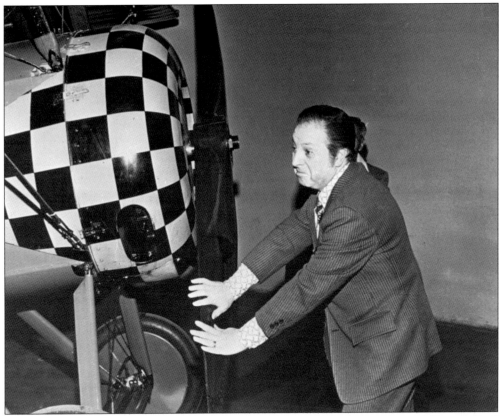

Nassau County executive Ralph Caso admires the aircraft exhibit at the coliseum's "Family Day" in 1973. Caso planned the first such event a year earlier on April 9, 1972, inviting the public to an open house with a free venue tour, souvenirs, and an ice-making demonstration. Stands sold hot dogs and sodas for 10¢ each, while beer cost 25¢. Pictured above, Caso touches the propeller of a 1918 Thomas-Morse S-4C. Pictured below, he sits in a 1931 Aeronca C-3. (Courtesy of the Nassau County Department of Parks, Recreation, and Museums, Photograph Archives Center.)

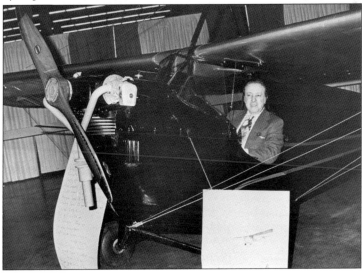

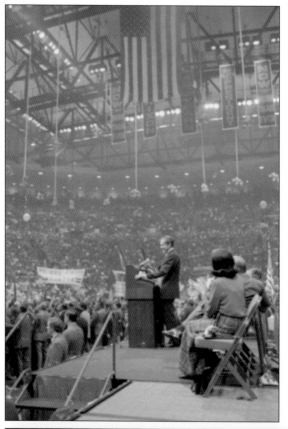

Signaling Nassau County's national prominence as a Republican stronghold, Pres. Richard Nixon continues his jam-packed tour of Westchester and Long Island with a coliseum speech on October 23, 1972. Pictured below, Nixon and his wife, Pat, wave to a raucous crowd of about 16,000 partisans beneath "Re-elect Nixon" and "Four More Years" banners. Preparations for his 8:00 p.m. address also included 10,000 noisemakers, 10,000 American flags, 17 bands, and an introduction by New York governor Nelson Rockefeller. Once Nixon took the lectern, he called for "honor and not surrender" in Vietnam and affirmed his vision of an all-volunteer army. Fifteen days later, Nixon crushed his Democratic opponent, South Dakota senator George McGovern, to win a second term. (Photographs by Ollie Atkins; courtesy of the Nixon Presidential Library and Museum and the National Archives and Records Administration.)

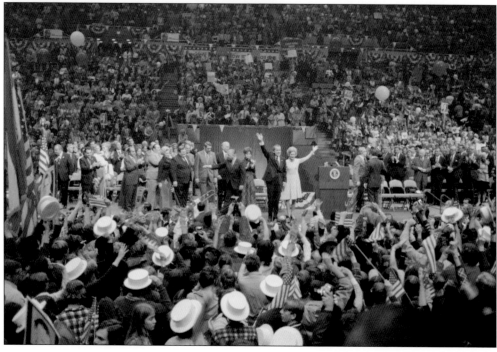

Two days before the hotly contested 1976 election, Pres. Gerald Ford rallies with supporters at a frenzied coliseum on Halloween night. "This is no time to play trick and treat with America," Ford told the boisterous crowd. After confidently inviting the cheering fans to his inauguration in January, Ford attacked his Democratic challenger, former Georgia governor Jimmy Carter, for what Ford branded "up-and-down" stances on whether to raise income taxes. Ford, who had become commander in chief after Richard Nixon resigned in 1974, also credited his administration for restoring faith in the White House following the Watergate scandal. But America voted for change. In a tight race, Carter captured 297 electoral votes—including New York State—to Ford's 240. (Courtesy of Gerald R. Ford Library.)

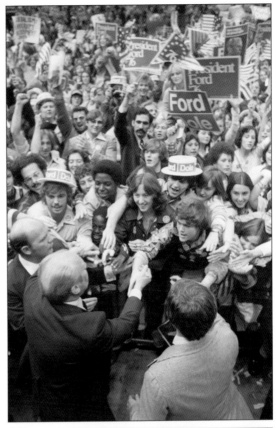

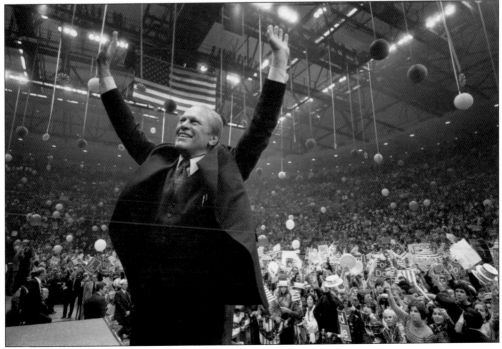

Coliseum workers prepare the arena for a Nassau Community College commencement in the 1990s. The Garden City institution, a unit of the State University of New York, shares the former Mitchel Field base with the coliseum and others. This image presents an Islanders logo decorating the scoreboard, while a POW/MIA flag hangs from the rafters in the upper left-hand corner. (Courtesy of Rich Walker.)

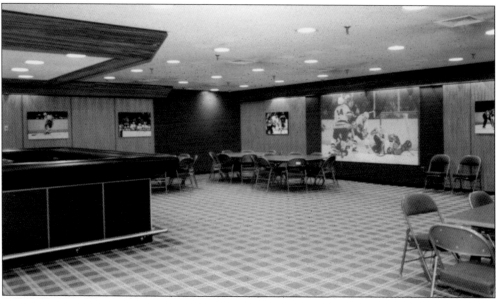

Off a hallway in the coliseum's executive offices, the MVP Room provided a spot for press conferences and private parties. In this photograph, light bathes the tables and cushioned folding chairs, as well as the Islanders scenes that line the walls. The grid carpeting resembles early visions for the arena's landscaped plaza. (Courtesy of Rich Walker.)

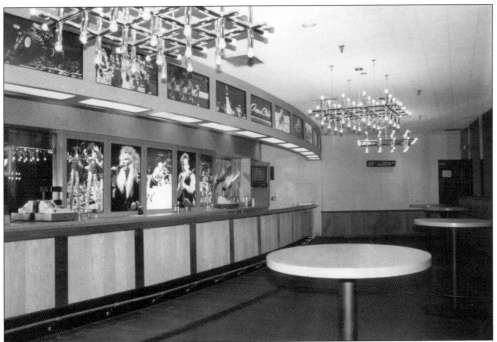

Located by the exhibition hall, the Arena Club restaurant served sit-down fare amid the coliseum's wealth of concession stands. In the early 1990s, the eatery also hosted a popular promotion with aid from the World Wrestling Federation. Fans paid $50 to park, see matches, score autographs from wrestlers, and dine at a kid-oriented buffet with chicken fingers and Jell-O. In the above photograph, backlit images by the bar display a monster truck, the circus, singers Stevie Nicks and Bruce Springsteen, and scenes from Islanders and lacrosse games. Through the years, the coliseum has also housed eateries such as the Blueline Bar and Grill and Doolin's Pub. (Courtesy of Rich Walker.)

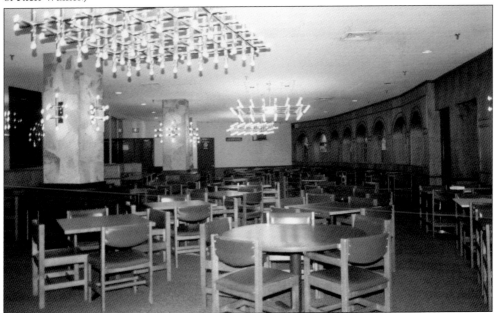

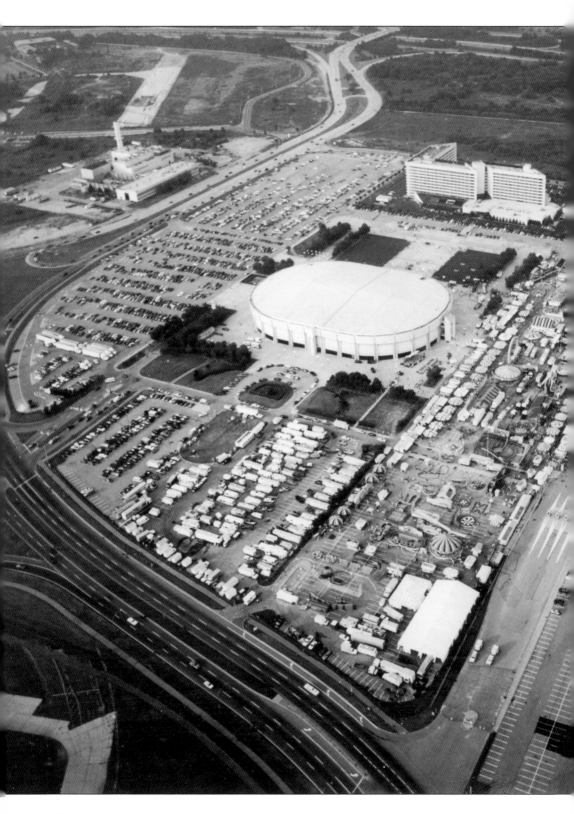

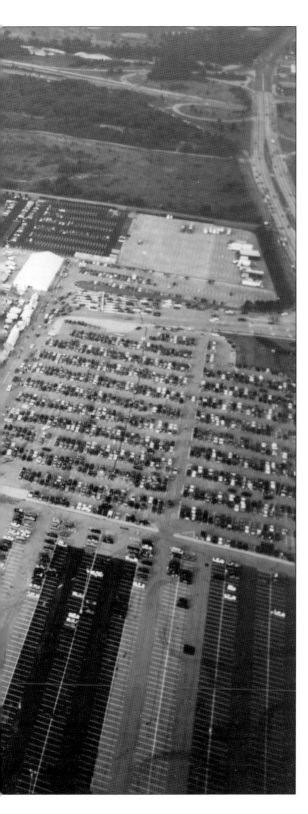

Cars stream into the coliseum's parking lot during a summertime fair in the 1990s. Known as the Nassau Coliseum Fair through most of the decade, the multitude of displays, games, and rides altered its title to the Nassau County Fair in 1997. Before the name switch, organizers invited visitors to watch pig races in 1991, explore an exhibit on lighting innovations in 1992, and take a whirl on an antique carousel in 1993. Recent incarnations have reverted to the label of Nassau Coliseum Fair. This photograph shows the remnants of a Mitchel Field runway in the upper left-hand corner. It also displays the roadways around the coliseum: the Meadowbrook Parkway across the top, Charles Lindbergh Boulevard on the left, Earle Ovington Boulevard at the bottom, and Hempstead Turnpike in the upper right. (Courtesy of Lance Elder.)

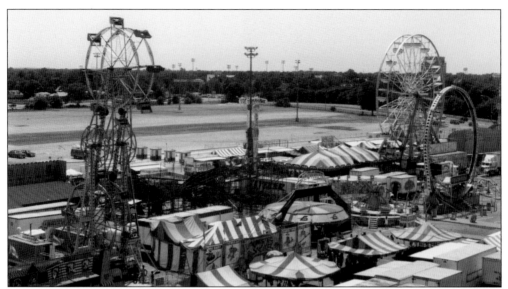

The coliseum lot transforms into a miniature amusement park for a 1990s fair. The Gravitron ride, seen near the center of these attractions, spun its patrons inside a cylinder. Centrifugal force held customers against side panels when the floor dropped out. A striped tent at the bottom of this shot touts monster snakes, while a sign to the far left refers to the Reithoffer Shows promoter. (Courtesy of Rich Walker.)

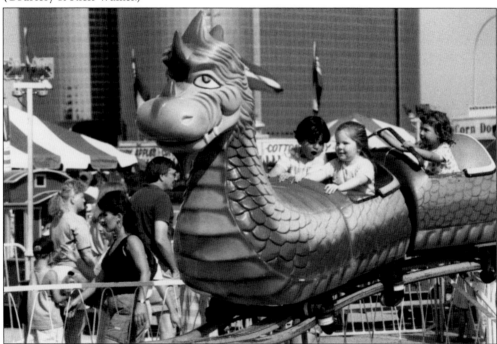

Young fairgoers brace themselves aboard a dragon ride in the coliseum lot. In the background stand the reflective glass towers of EAB Plaza, an office complex that opened in 1983. EAB sold the site in 2005 to the Reckson Associates Realty Corporation, which became RXR Realty after a merger. RXR executive Scott Rechler soon partnered with Islanders owner Charles Wang on redevelopment plans for the area. (Courtesy of Rich Walker.)

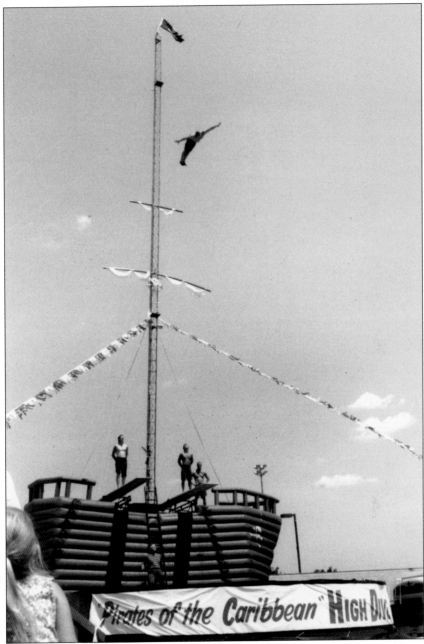

A professional high diver leaps from plank to pool during the "Pirates of the Caribbean" act at the fair in the 1990s. Other shows through the years have incorporated bicycle stunts, circus tricks, and even the Harlem Globetrotters. Perhaps no spectacle, however, generated as much buzz as a 1997 visit from Miss Americow. In a twist that spared the bovine from a meat grinder, she was born with a spot on her side that resembled a map of the United States. Miss Americow appeared at the Uniondale fair on her first national tour, imparting "a lesson in geography and agriculture at the same time," as a coliseum official told the *New York Times*. In recent years, the fair has featured fireworks, karate demos, magic acts, and exotic animals. The menagerie in 2008 included a kangaroo, lions, llamas, monkeys, and tigers. (Courtesy of Rich Walker.)

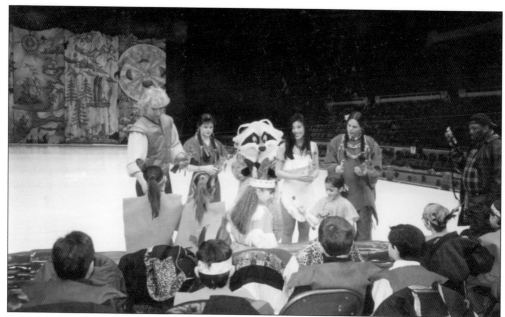

Cast members from *The Spirit of Pocahontas*, an ice show based on the Walt Disney film, greet young admirers at the coliseum in January 1997. Joanna Ng played the Indian heroine opposite Sergei Petrovski as English adventurer John Smith, skating to a score highlighted by the 1995 Oscar-winning song "Colors of the Wind." Here Meeko the raccoon flanks the spectacle's stars. (Courtesy of Rich Walker.)

This panel on the coliseum's facade flaunts a logo that has appeared in countless arena advertisements. Alongside the names of the venue and its county-picked operator SMG, the decal displays a pair of semicircles, one teal and one red, around smaller semicircles of blue and yellow. In another recent emblem, the coliseum's title accompanies an illustration of an exterior segment of the arena. (Photograph by the author.)

Two

THE MUSICAL BUTTERFLY

Reporters who covered the coliseum's first-ever event in 1972 ceded to an unusual request. Though the Nets' debut at the arena offered an inaugural glimpse inside, management wanted journalists to qualify the game as an unofficial opening. Nassau County executive Ralph Caso justified the plea. He described the basketball tip-offs in February and March as part of the coliseum's "cocoon" phase. The "butterfly," he explained, would not flutter until a musical act in April.

As time passed, details of the introductory concert remained vague. Venue officials teased with mentions of "an entertainment world blockbuster." Caso suggested the county might book Grammy Award winner Barbra Streisand or the iconic Elvis Presley. Newspapers reported negotiations with Johnny Cash, Engelbert Humperdinck, Tom Jones, Lawrence Welk, and Led Zeppelin. Before inking a single contract, coliseum brass ambitiously predicted a four-day slate of opening events.

Despite the county's aspirations, other arenas did not express fears about losing concerts to Uniondale. Many insisted the coliseum would either not affect or actually aid their business. A Madison Square Garden spokesman surmised that Nassau residents would develop a taste for arena events at the coliseum and start frequenting its Manhattan counterpart. The owner of the Long Island Arena in Commack figured that acts unable to fill the coliseum would seek his 4,000 seats. At the Westbury Music Fair, management declared an unflinching monopoly on book musicals that sought intimate, non-arena settings. Music Fair co-owner Lee Guber told *Newsday* he might even send congratulatory hockey pucks to the coliseum's general manager, Earl Duryea, on opening night.

Discontent, however, centered on music that no Long Island venue could offer. Early plans for Mitchel Field had envisioned a coliseum and a 2,100-seat concert hall as part of the proposed John F. Kennedy Educational, Civic, and Cultural Center. Architects named an acoustical consultant in 1965, but the county later cut costs by scrapping structures such as the concert hall. Without one, critics groaned, the region would never attract the most renowned dance troupes or opera companies.

In fact, the county could not even snare a musical headliner for the coliseum's opening. Instead those honors went to the Ice Follies on April 12. Before long, though, some of the world's most popular performers would grace the Uniondale stage.

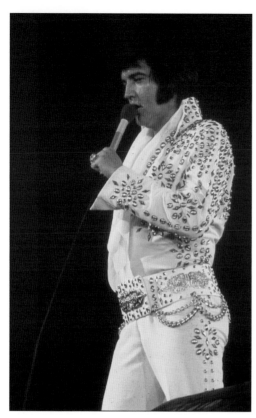

Reigning as "King of Rock and Roll," Elvis Presley sports a rhinestone-studded jumpsuit during a series of coliseum concerts in June 1973. Loge seats sold for $10, as seen on these unused tickets, with Presley performing his own hits and contemporary tunes such as "Bridge Over Troubled Water." His ballooning physique contrasted with the slim 1950s frame that rocked to pelvis-gyrating renditions of "Hound Dog" and "Jailhouse Rock." Presley died at age 42 on August 16, 1977, just six days before his next scheduled performance at the coliseum. About 5,000 fans packed the arena's parking lot for a four-hour memorial service on the night he was to play. Most never redeemed their tickets. (Left, courtesy of Joseph T. Farriella; below, courtesy of Lance Elder.)

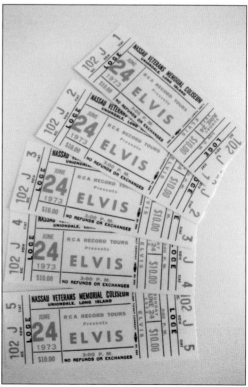

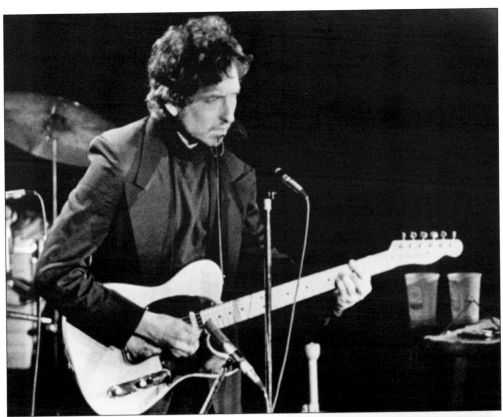

Bob Dylan strums his guitar at the coliseum on January 29, 1974, during a six-week tour with The Band. Often defined by his songwriting prowess and raw vocals, Dylan delighted Long Island fans with favorites such as "Knockin' On Heaven's Door," "The Times They Are A-Changin'," and "Like A Rolling Stone." (Courtesy of AP/Wide World Photographs.)

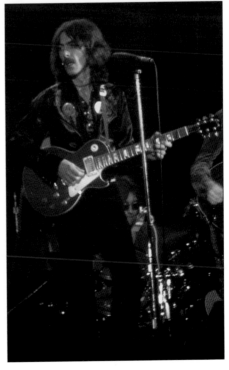

On the first American tour by a former Beatle, George Harrison plays the coliseum on December 15, 1974, in one of his two concerts at the venue that day. Harrison teamed on the tour with keyboardist Billy Preston, who collaborated with the Beatles on the 1969 single "Get Back" and recorded his own hits "Nothing From Nothing" and "Will It Go Round in Circles." (Courtesy of Joseph T. Farriella.)

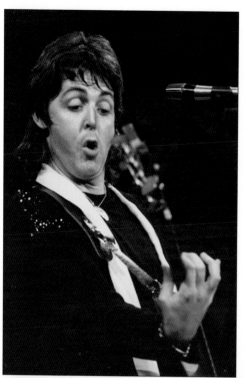

Paul McCartney gazes at his guitar on May 21, 1976, when the ambitious Wings Over America tour stopped at the coliseum. The concert marked McCartney's first performance in the New York area since the Beatles' protracted break-up that dragged from the late 1960s into the 1970s. Wings also played two nights on the tour at Madison Square Garden. (Courtesy of AP/Wide World Photographs.)

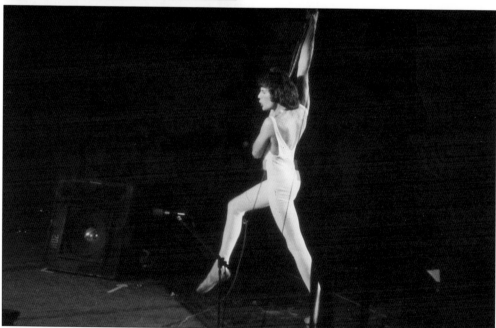

Freddie Mercury powers Queen's A Day at the Races tour into the coliseum on February 6, 1977. The British rock band was on the cusp of releasing "We Are the Champions," appropriate for the home arena of the New York Nets, titleholders in the American Basketball Association in 1974 and 1976. Mercury died at age 45 in 1991, days after announcing he had AIDS. (Courtesy of Joseph T. Farriella.)

Eric Clapton, praised as one of the world's most influential guitarists, performs at the coliseum on April 3, 1978. With stints on the Yardbirds and Cream behind him, Clapton assembled a band on this tour with George Terry on second guitar, Dick Sims on keyboards, Carl Radle on bass, Jamie Oldaker on drums, and Marcy Levy on vocals. (Photograph by Joe Farrington; courtesy of the *New York Daily News*.)

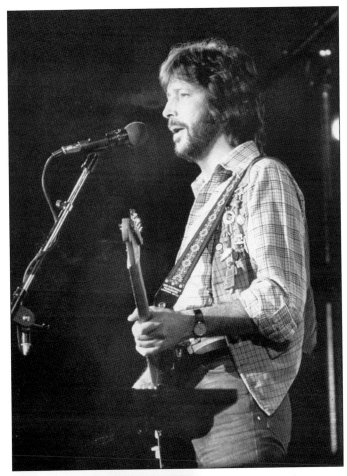

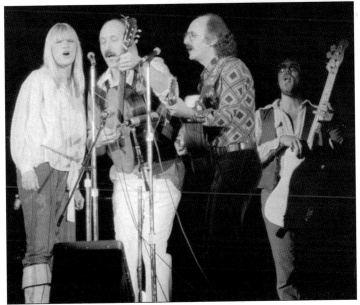

Peter, Paul, and Mary take contemporary folk music to the coliseum on April 9, 1978, to benefit the Performing Arts Foundation of Huntington, Long Island. From left to right, Mary Travers, Paul Stookey, and Peter Yarrow parted ways in 1970 to pursue solo careers but reunited eight years later. The politically active trio parlayed songs like "Puff the Magic Dragon" into mainstream success. (Courtesy of AP/Wide World Photographs.)

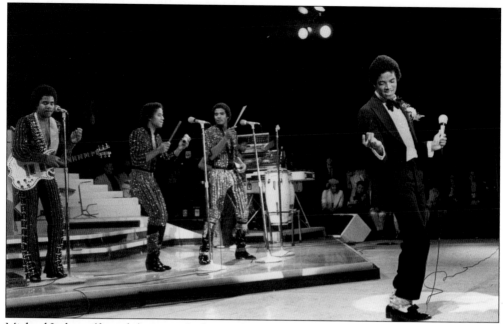

Michael Jackson (far right) taps to the beat as he and his brothers, Tito, Marlon, and Jackie, play the coliseum in 1979. Joined with another sibling, Jermaine (not pictured), the Jackson 5 gained prominence with "I Want You Back" and "ABC." Michael Jackson later embarked on an epic solo career. He died at age 50 in 2009. (Photograph by Ebet Roberts; courtesy of Getty Images, Redferns Collection.)

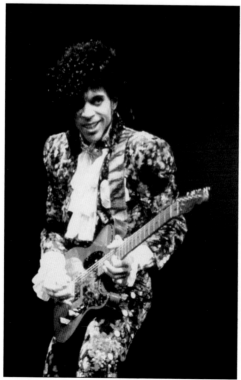

"Purple Rain" poured upon the coliseum masses when Prince jammed a well-received, six-show set in March 1985. His part-funk, part-rock rhythm, which critics hailed for appealing to both black and white listeners, was on display the previous year in a movie that bore the same name as his album and tour. (Photograph by Ebet Roberts; courtesy of Getty Images, Redferns Collection.)

Bruce Springsteen and the E Street Band barrel through the Tunnel of Love Express tour at the coliseum on April 1, 1988. The New Jersey rocker invigorated the crowd with tracks like "Born in the USA" and "Glory Days." Tickets for his two shows in Uniondale had sold out in less than 90 minutes in March. (Photograph by Richard Corkery; courtesy of the *New York Daily News*.)

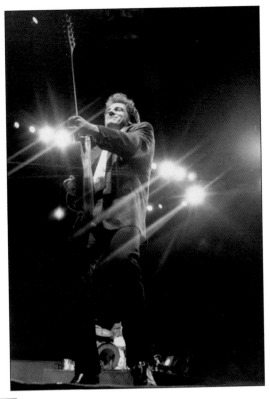

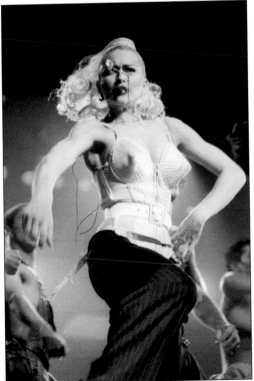

Madonna favors a cone bra, belt, and pinstriped pants during the coliseum leg of her Blond Ambition world tour on June 11, 1990. The provocative pop icon strutted onto stages from Tokyo to Los Angeles to Paris flaunting an arsenal of hits highlighted by the controversial chart-topper "Like a Prayer." She scheduled three consecutive nights at the coliseum but none at Madison Square Garden. (Courtesy of AP/Wide World Photographs.)

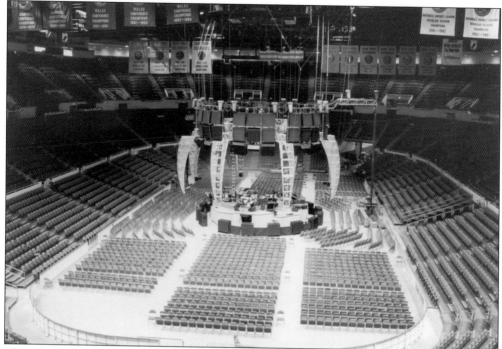

The coliseum stage and floor seats await a unique "concert in the round" by the English rock band Yes on April 20, 1991. Performers had traditionally occupied a platform on one end of the arena, with some seats behind them blocked off. Constructing the Yes stage at center ice proved complicated, but offered a higher seating capacity and better views for fans. (Courtesy of Rich Walker.)

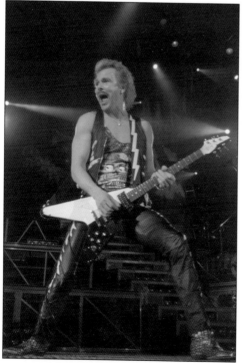

Rudolf Schenker of Scorpions injects a heavy metal brand of venom into the coliseum on May 3, 1991. At the time, the German band behind "Rock You Like a Hurricane" also included frontman Klaus Meine, bassist Francis Buchholz, guitarist Matthias Jabs, and drummer Herman Rarebell. Scorpions shared the Uniondale billing that night with the hard rock group Trixter. (Courtesy of Rich Walker.)

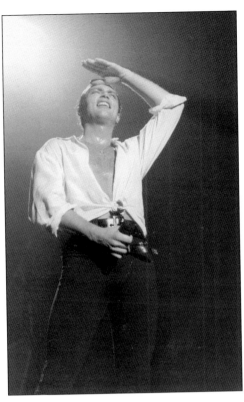

Geoff Tate (right) and Eddie Jackson (below) fuel the heavy metal band Queensrÿche at the coliseum on July 26, 1991. Hailed for the 1990 power ballad "Silent Lucidity," the group then featured Tate on vocals, Jackson on bass, Scott Rockenfield on drums, and Chris DeGarmo and Michael Wilton on guitar. Queensrÿche's dystopian lyrics gave way the next night in Uniondale to country music specialists Hank Williams Jr. and Sawyer Brown. Six weeks later, Queensrÿche rocked live at the internationally broadcast MTV Video Music Awards. Among the other awards show acts were Metallica and Van Halen, two bands that soon visited the coliseum. (Courtesy of Rich Walker.)

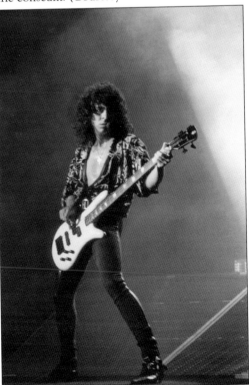

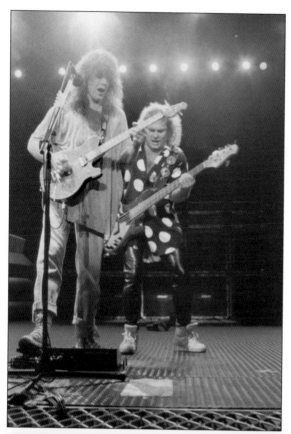

At left, Eddie Van Halen (left) and bassist Michael Anthony of the heavy-metal juggernaut Van Halen jam at the coliseum on October 27, 1991. Pictured below, Eddie Van Halen rocks with frontman Sammy Hagar, who joined the band after David Lee Roth's exit in 1985. Not pictured is drummer and crew cofounder Alex Van Halen. The enduring group, seen here promoting its album *For Unlawful Carnal Knowledge*, has made several Uniondale stops with various personnel throughout the decades. The grunge band Alice in Chains, led by guitarist Jerry Cantrell and vocalist Layne Staley, also took the stage that night. (Courtesy of Rich Walker.)

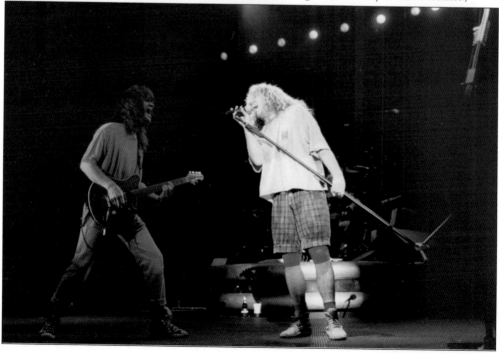

Tom Petty and the Heartbreakers visit the coliseum with blues singer and guitarist Chris Whitley on October 8, 1991. Petty worked in tracks from his new album, *Into the Great Wide Open*, with songs from throughout his career. Seventeen years later, the National Football League called upon Petty's band to deliver a "Free Fallin' " halftime show at Super Bowl XLII in 2008. (Courtesy of Rich Walker.)

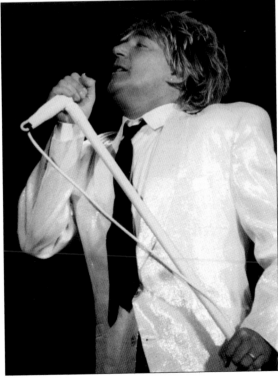

Rod Stewart stays "Forever Young" at the coliseum for consecutive nights on November 12–13, 1991. The British warbler's raspy delivery of hits such as "Maggie May" and "Every Picture Tells a Story" led to stardom in the early 1970s. His popularity remained two decades later, as did his distinctive blond locks. (Courtesy of Rich Walker.)

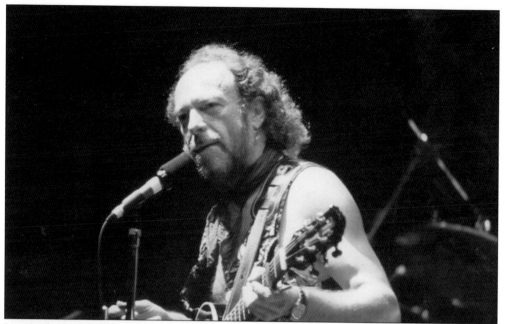

Ian Anderson of the rock group Jethro Tull strides into the coliseum with Chrissy Steele on November 14, 1991. Anderson, who was born in Scotland, formed the band in 1968 and served as its lead singer and flutist on breakthrough hits like "Aqualung," "Benefit," and "Thick as a Brick." (Courtesy of Rich Walker.)

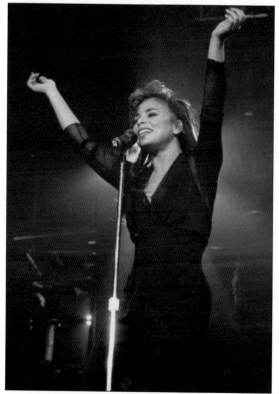

Paula Abdul serenades the coliseum masses on November 17, 1991. Abdul mounted a tour of 29 cities with the aid of 11 tractor-trailers, 9 buses, 9 musicians, 8 dancers, 2 stilt walkers, a publicist, and several managers, to list just a few components. She eclipsed her performing fame, however, during an eight-year run as a compassionate judge of amateur singers on the television show *American Idol*. (Courtesy of Rich Walker.)

Metallica frontman James Hetfield (right) and drummer Lars Ulrich (below) vibrate the coliseum during a three-night stand from December 18 to 20, 1991. Rounded out by guitarist Kirk Hammett and bassist Jason Newsted, the thrash metal quartet arrived in Uniondale amid complaints that its ballads had become too basic and trite. Critics noted the band's last album, titled *Metallica*, strayed from the progressive hits the group released in the early 1980s. Instead, the new tracks focused on hard-rock riffs that, while topping the Billboard charts, created the perception among some that Metallica sold out. With a chance to assure its hard-core base at the coliseum, Metallica jammed on a diamond-shaped stage with about 100 fans in a "snake pit" at the center. Hetfield led a 2.5-hour set that included "Creeping Death" and "Seek and Destroy." (Courtesy of Rich Walker.)

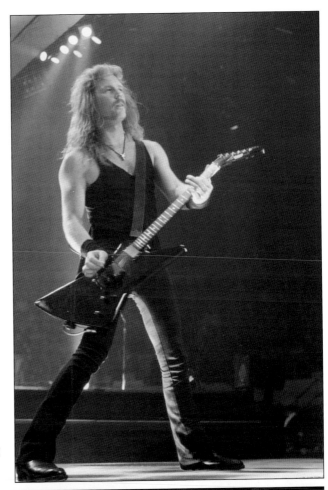

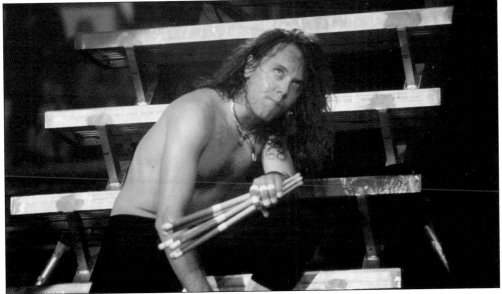

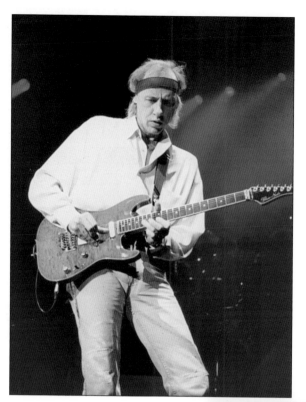

Mark Knopfler of the rock band Dire Straits eyes his Pensa-Suhr guitar at the coliseum on February 28, 1992. Touring to promote the album *On Every Street*, the British group boasted a nine-piece lineup that centered on Knopfler, Alan Clark and Guy Fletcher on keyboards, and John Illsley on bass. But Dire Straits encountered disappointing crowds and unenthusiastic reviews and eventually went on hiatus. (Courtesy of Rich Walker.)

Bono guides U2's Zoo TV tour into the coliseum on March 9, 1992. The Irish rock band, which rarely embraced props, strove to reinvent its image that night by suspending six cars with light equipment over the stage. Bono, in black leather and sunglasses, strutted down a runway towards the crowd. U2 began the concert with eight songs from *Achtung Baby*, its first album since 1988. (Courtesy of Rich Walker.)

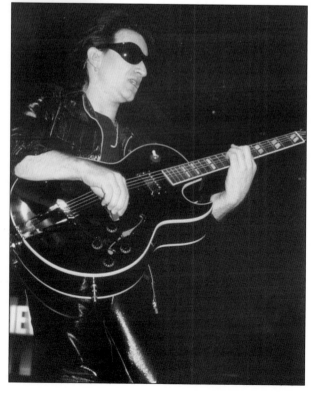

Jerry Garcia lends psychedelic sounds during the Grateful Dead's three-night coliseum stint from March 11 to 13, 1992. The freewheeling band consisted at the time of Garcia on lead guitar and vocals, Bob Weir on rhythm guitar, Bruce Hornsby and Vince Welnick on keyboards, Phil Lesh on bass, and Mickey Hart and Bill Kreutzmann on drums. Garcia died of a heart attack at age 53 in 1995. (Courtesy of Rich Walker.)

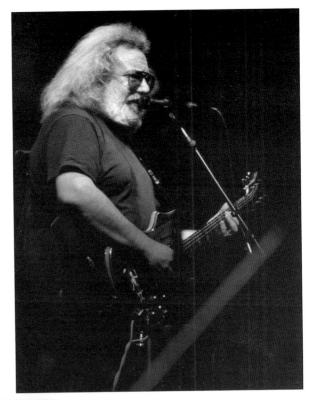

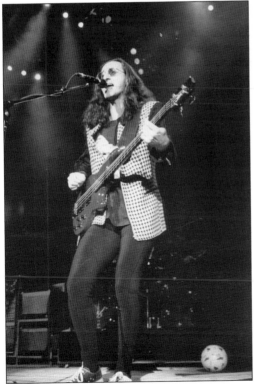

Geddy Lee fronts the Canadian rock trio Rush at the coliseum on March 15, 1992. Lee, guitarist Alex Lifeson, and drummer Neil Peart publicized the band's *Roll the Bones* album, which contained the lively hit "Dreamline." Long Island became a favorite and frequent tour stop for Rush, which debuted with a self-titled compilation in 1974 and entered the Canadian Music Hall of Fame in 1994. (Courtesy of Rich Walker.)

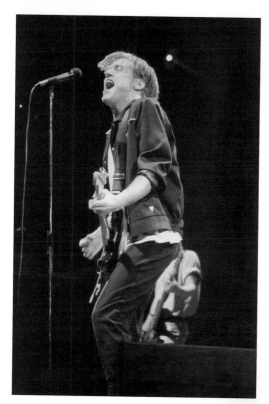

Bryan Adams hypes his *Waking Up the Neighbours* album in the coliseum on March 25, 1992. After the Canadian singer unleashed hits in the mid-1980s, he surged to a new pinnacle of popularity with the 1991 release of his single "(Everything I Do) I Do It for You." The Grammy Award–winning tune, created for the film *Robin Hood: Prince of Thieves*, topped charts around the world. (Courtesy of Rich Walker.)

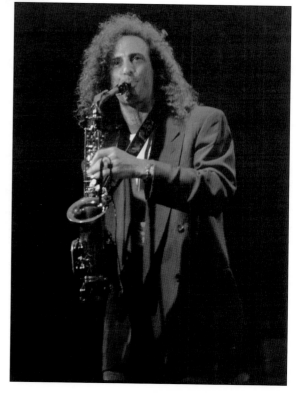

Kenny G soothes coliseum admirers with his saxophone on August 31, 1993. The Long Island crowd was also treated that night to singer Peabo Bryson, known for vocals on Disney themes such as "Beauty and the Beast." Six months after their Uniondale concert, both artists snared Grammy Awards—Kenny G for the instrumental composition "Forever in Love" and Bryson for "A Whole New World" from *Aladdin*. (Courtesy of Rich Walker.)

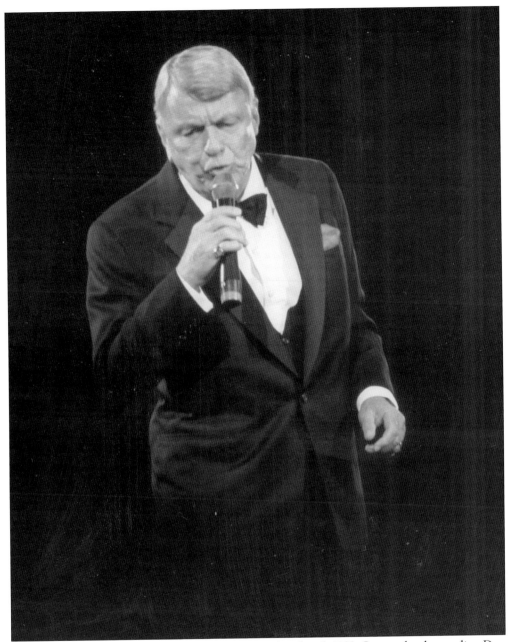

Frank Sinatra grooves in the coliseum at age 77 on October 6, 1993. Queens-bred comedian Don Rickles also entertained the audience that night. In Uniondale two years earlier, on November 15, 1991, the stately Sinatra had opened with the 1953 tune "I've Got the World on a String" before announcing his approach to the concert. "I'm not going to do much that's new tonight, because there's nothing new that's decent," he told the crowd, according to the New York Times. Sinatra, known as Ol' Blue Eyes, followed with hits such as "The Lady is a Tramp," "The Best is Yet To Come," and "Theme from New York, New York." He also joked about growing old, saying he had forgotten composers' names and stiffly picking up a microphone that he dropped. Sinatra died at age 82 in 1998. (Courtesy of Rich Walker.)

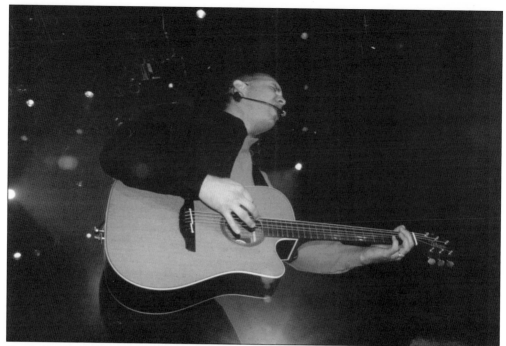

Garth Brooks infuses country into the coliseum on November 10, 1993. Surrounded by smoke machines and multi-colored lights, the affable artist in a cowboy hat combined elements of pop and folk. He also paid homage to a Long Island favorite, Billy Joel, by singing "New York State of Mind." Tickets cost just $18, about half the standard price, in a nod to Brooks's middle-class appeal. (Courtesy of Rich Walker.)

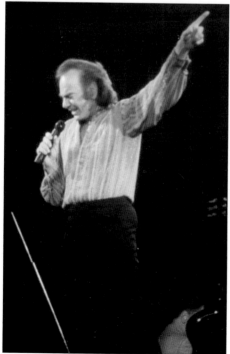

Neil Diamond relishes the rhythm at the coliseum on November 23, 1993. The "Sweet Caroline" singer journeyed to Uniondale on a tour pushing his album *Up on the Roof: Songs from the Brill Building.* Born in Coney Island, Diamond merited induction in 2008 into the Long Island Music Hall of Fame, which covers Brooklyn and Queens as well as Nassau and Suffolk Counties. (Courtesy of Rich Walker.)

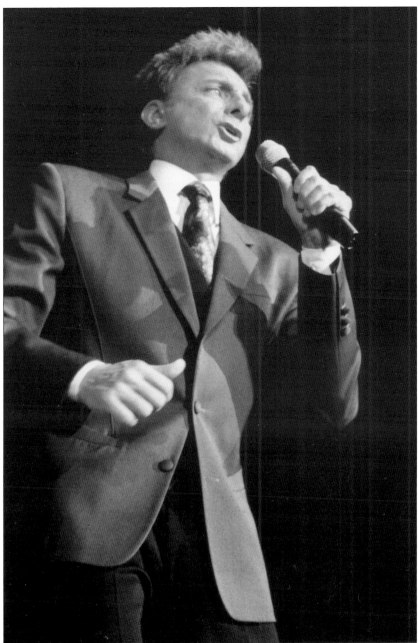

Barry Manilow intoxicates coliseum boosters on October 27, 1995. The Brooklyn-born crooner was a consistent chart-topper in the 1970s, releasing hits such as "I Write the Songs," "Looks Like We Made It," and "Can't Smile Without You." His early popularity led to sellouts at numerous arenas, including two shows in the round at the coliseum in 1981. At those concerts, Manilow mixed his signature tunes like "Mandy" and "Weekend in New England" with more recent tracks. Manilow was inducted into the Songwriters Hall of Fame in 2002 and launched a hugely successful show at the Las Vegas Hilton in 2005. On a return to the coliseum in 2009, the sentimental warbler promoted his latest album, *The Greatest Songs of the Eighties,* which included a cover of Stevie Wonder's single "I Just Called to Say I Love You." (Courtesy of Rich Walker.)

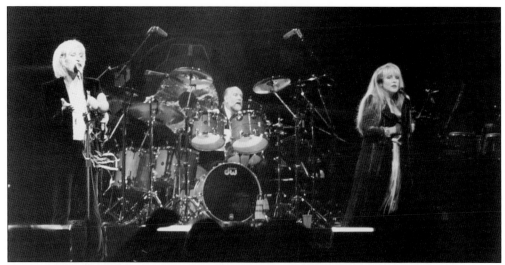

Fleetwood Mac roars into the coliseum with, from left to right, Christine McVie, Mick Fleetwood, and Stevie Nicks on September 23, 1997. A recording of crickets curiously played over the speakers before the British-American band rocked Uniondale with "Go Your Own Way," "Gold Dust Woman," and "Songbird." The group's personnel changed often through the years, but its Long Island lineup featured the best-known members. (Courtesy of Rich Walker.)

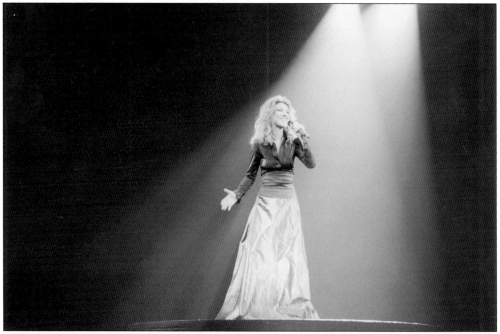

Céline Dion shines beneath the coliseum spotlights on August 31, 1998. Known for her bittersweet love ballads, the Canadian songstress had soared in popularity the previous year with "My Heart Will Go On," the theme of the 1997 blockbuster movie *Titanic*. Dion wedged the Long Island show between stops at Continental Airlines Arena in New Jersey and Madison Square Garden. (Courtesy of Rich Walker.)

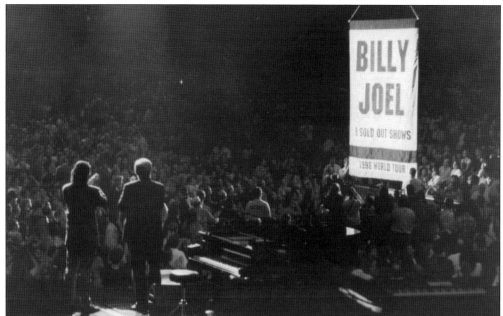

The regular crowd shuffled into the coliseum so many times for Billy Joel concerts that the Levittown-raised "Piano Man" remains permanently linked to the venue. Whether tickling the ivories on "Just the Way You Are" or "New York State of Mind," Joel always returned to his roots with swagger and spirit. Sometimes he rocked out for a cause. He hosted the first "Charity Begins at Home" benefit on May 28, 1979, for an organization he started to raise funds for Long Island nonprofits. Pictured above, fans watch the unfurling of a banner to commemorate Joel's nine consecutive sellouts on his world tour in 1998. The tribute met the Islanders' retired numbers and championship salutes in the rafters. (Courtesy of Rich Walker.)

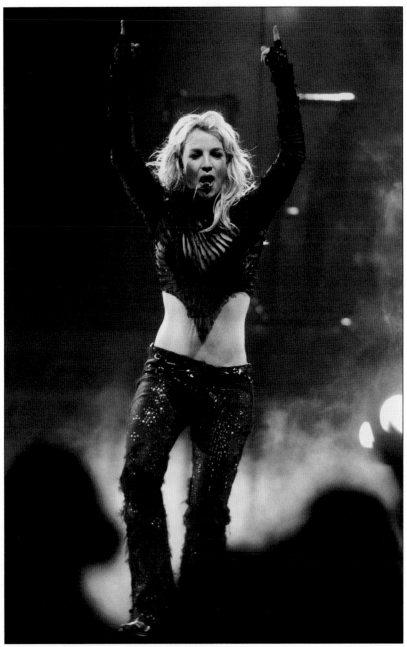

Britney Spears points skyward while rousing the coliseum crowd on November 7, 2001. Her 90-minute show, with the fantasy theme of "dream within a dream," saw Spears shimmy across the stage in the attires of an acrobat, cowgirl, and marionette. The 19-year-old pop princess also dressed as a sex slave and declared, "I'm not a little girl anymore," according to the *New York Daily News*. Surrounded by 30 video screens and countless laser lights, Spears sang "Oops! . . . I Did It Again," ". . . Baby One More Time," and "I'm a Slave 4 U," among other singles. Near the end of "I Love Rock 'n' Roll," the coming-of-age star did flips while suspended from bungee cords. Her tour promoted *Britney*, which was nominated for best pop vocal album at the 2003 Grammy Awards. (Photograph by John Roca; courtesy of the *New York Daily News*.)

Three

INTRODUCING

THE ISLANDERS

Plans for a rink at Mitchel Field spurred speculation the Long Island Ducks would wade there someday. Skating in the scrappy Eastern Hockey League, the beloved Ducks embodied the rough-and-tumble era that inspired the movie *Slap Shot*. When the team clinched its lone play-off title in 1965, a crowd of 4,000 packed the Long Island Arena in Commack. But like the Nets, languishing at the leaky Island Garden, the Ducks hoped to escape to a more modern home.

Nassau County, however, set a loftier goal for the coliseum. Painting the venue as Long Island's answer to Madison Square Garden, county executive Ralph Caso wanted a National Hockey League club to rival the New York Rangers. Anything less, said coliseum consultant William Shea, "would deteriorate the building." A decade earlier, Shea had persuaded Major League Baseball to award an expansion team, the Mets, to New York City. His threats then to form a new league pressured the baseball establishment into growth. A similar strategy would convince the NHL to swell in the early 1970s.

This time, Shea did not need to propose a rival league. To gain leverage with the NHL, he simply met with the upstart World Hockey Association. Its commissioner pledged the WHA would request only a nominal fee for a Long Island franchise, whereas the Rangers demanded an indemnification charge of at least $5 million to allow another NHL team into its territory. A coliseum club would lend credibility to the fledgling WHA, so the NHL intervened. On November 9, 1971, the league announced expansion into two markets: Atlanta and Long Island.

Caso welcomed the news, if not its delivery. *Newsday* reported the league's president, Clarence Campbell, irritated Caso at a press conference by labeling him the county "commissioner" and "head of the Nassau Coliseum." As the media prepared to leave, Caso reminded them he ran "the whole county." He cared more, though, about another title. Caso prodded the team's first owner, Roy Boe, to pick Long Island as its affiliation over New York. They settled on the New York Islanders, wearing county colors of blue and orange with a Long Island map on the logo.

Critically, Boe also hired Bill Torrey as general manager to lead the Islanders into the expansion draft.

Bill Torrey, a former executive with the Oakland Seals, became the Islanders' inaugural general manager on February 15, 1972. The often bow-tied Torrey focused on defense at the June 6 expansion draft. He chose Chicago Black Hawks netminder Gerry Desjardins and Montreal Canadiens blueliner Bart Crashley with the Islanders' first picks in the respective goalie and non-goalie rounds. (Photograph by Anthony Neste; courtesy of Getty Images, *Sports Illustrated* Collection.)

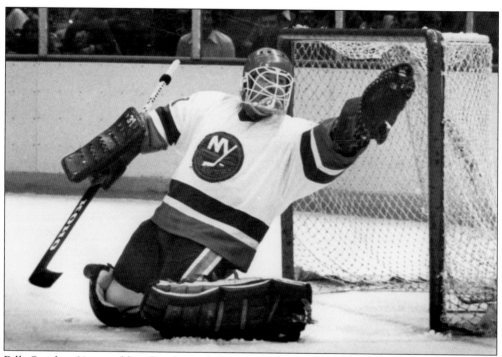

Billy Smith, a 21-year-old goaltender in the Los Angeles Kings organization, went to the Islanders in the 1972 expansion draft. In five NHL games the previous season, the rookie earned just one win while posting an unimpressive 4.60 goals-against average. At the draft, the Islanders also reached a deal with the Montreal Canadiens for minor league keeper Glenn Resch, soon to be known as "Chico." (Courtesy of Jackson B. Pokress.)

Ed Westfall, seen here in the No. 18 jersey, reigned as the Boston Bruins' premier penalty-killer when the Islanders snatched him in the 1972 expansion draft. He served as the Islanders' inaugural captain and scored the franchise's first regular-season goal on October 7, 1972, during a 3-2 loss to the Atlanta Flames at the coliseum. (Courtesy of the Nassau County Department of Parks, Recreation, and Museums, Photograph Archives Center.)

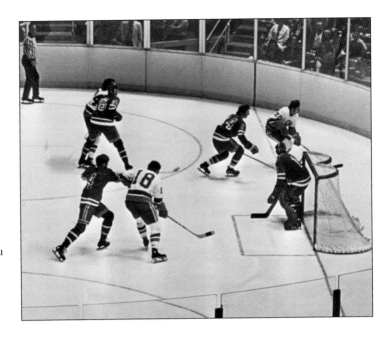

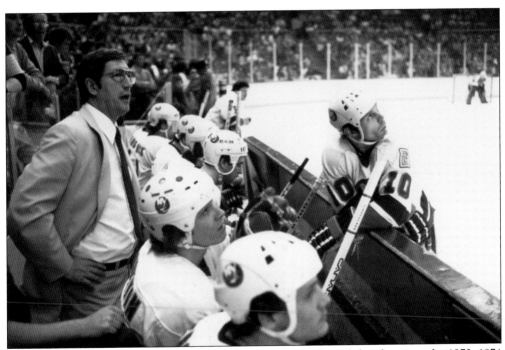

Al Arbour, pictured behind the Islanders' bench, was named coach heading into the 1973–1974 season. His predecessors, Phil Goyette and Earl Ingarfield, had bombed in the franchise's inaugural campaign, combining for a 12-60-6 record, then the worst in NHL history. Arbour, a former defenseman, helmed the Islanders to an improved 19-41-18 mark in his first year. (Photograph by George Tiedemann; courtesy of Getty Images, *Sports Illustrated* Collection.)

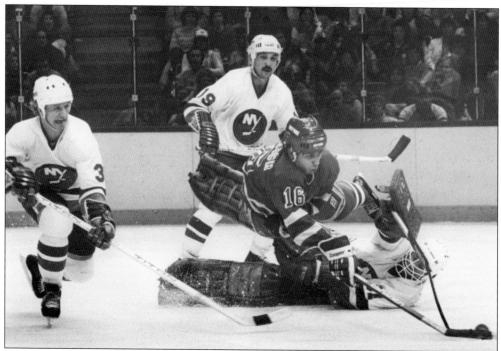

Bryan Trottier (center), picked by the Islanders in the 1974 draft, watches goaltender Billy Smith attempt to stop the New York Rangers' Mark Pavelich. At left is defenseman Tomas Jonsson. Trottier played junior hockey during the 1974–1975 season, marked by the Islanders' first winning record and play-off appearance. The Islanders ousted the Rangers and Pittsburgh Penguins before losing in the semifinals to the Philadelphia Flyers. (Courtesy of Jackson B. Pokress.)

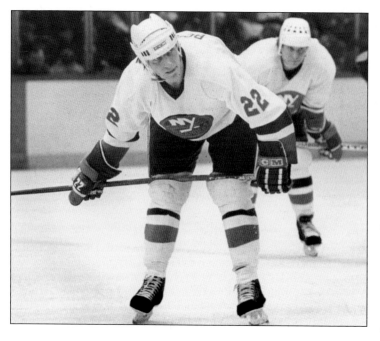

Mike Bossy, the Islanders' first-round pick in the 1977 draft, hunches over the ice before a face-off. Club officials hoped the high-scoring winger would complement a strong defense in Uniondale. In the second round, the Islanders chose center John Tonelli of the rival World Hockey Association. He played out the final year of his WHA contract before signing with New York in 1978. (Courtesy of Jackson B. Pokress.)

Mike Bossy drives to the net against New York Rangers goaltender John Davidson. Phil Esposito, seen at left following the play, ended his Hockey Hall of Fame career in Manhattan at the same time that Bossy rose to stardom on Long Island. Bossy scored 53 goals in the 1977–1978 campaign, smashing the rookie record of 44. The next year, he notched 69 goals and 57 assists. (Courtesy of Jackson B. Pokress.)

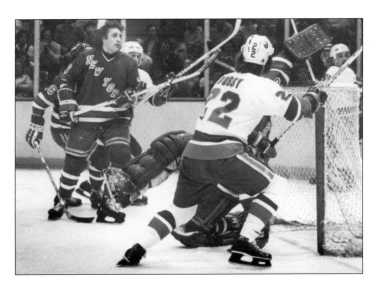

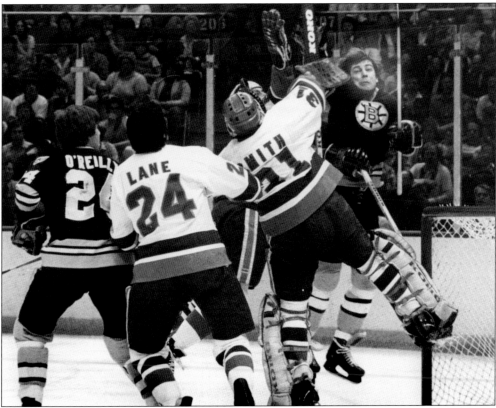

Billy Smith leaps for an airborne puck during a game versus the Boston Bruins at the coliseum. Skating at left are Bruins enforcer Terry O'Reilly and Islanders blueliner Gord Lane. New York secured Lane from the Washington Capitals in December 1979, strengthening the defense corps during a play-off run. The following spring, the Islanders landed all-star center Butch Goring from the Los Angeles Kings. (Courtesy of Jackson B. Pokress.)

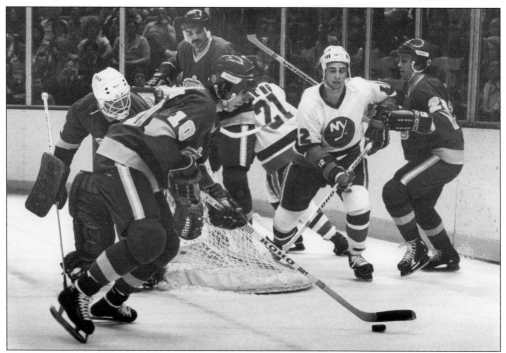

Steve Carlson of the Los Angeles Kings controls the puck in a first-round play-off series against the 1979–1980 Islanders. Three years earlier, Carlson starred in the cult movie *Slap Shot* as an overzealous Hanson brother. Carlson scored the lone postseason tally of his NHL career as the Kings routed the Islanders in game two at the coliseum. Nevertheless, New York prevailed in the series. (Courtesy of Jackson B. Pokress.)

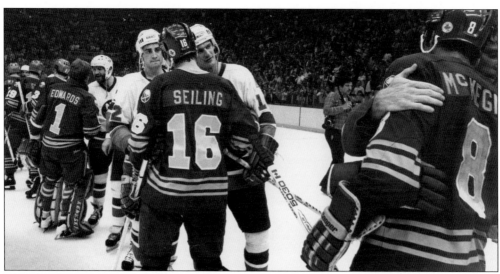

The Islanders shake hands with the Buffalo Sabres after New York clinched the 1980 semifinals on May 10. Among those exchanging postgame pleasantries are the Islanders' Duane Sutter (No. 12) and Bob Bourne (No. 14), both pictured with Sabres right wing Ric Seiling. The 5-2 win at the coliseum advanced the Islanders to the Stanley Cup championship round for the first time in franchise history. (Courtesy of Jackson B. Pokress.)

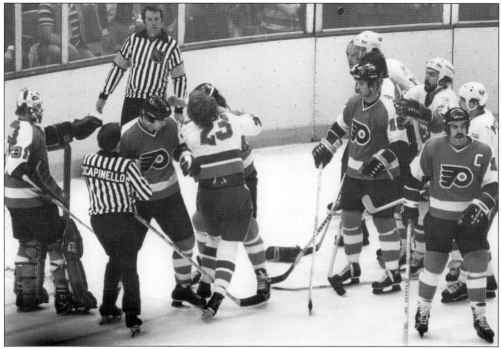

In the coliseum's first Stanley Cup finals match, Islanders right wing Bob Nystrom fights the Philadelphia Flyers' Mike Busniuk on May 17, 1980. Linesman Ray Scapinello rushes to break up the scuffle in game three of the series. The teams split the first two in Pennsylvania before this heated contest. Defenseman Denis Potvin's two power-play goals sparked New York in a 6-2 romp. (Courtesy of Jackson B. Pokress.)

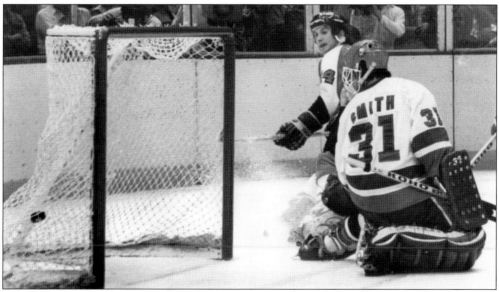

Flyers center Ken Linseman, skating in his first Stanley Cup finals, eyes a puck that eluded the Islanders' Billy Smith. Linseman potted his only goal of the series in game four on May 19, 1980, but Smith halted 34 shots in a 5-2 Islanders triumph at the coliseum. The Flyers captured game five in Philadelphia, setting up a crucial game six on Long Island. (Courtesy of Jackson B. Pokress.)

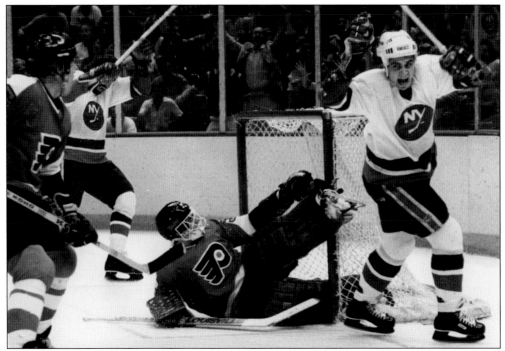

Duane Sutter (right) celebrates a controversial goal in game six of the Stanley Cup finals on May 24, 1980. Clark Gillies, seen raising his arms at left, began the first-period play by passing the puck backward over the blue line to Butch Goring. Linesman Leon Stickle missed the offside call as Goring carried the puck back into the Flyers' zone and fed to Sutter. (Courtesy of Jackson B. Pokress.)

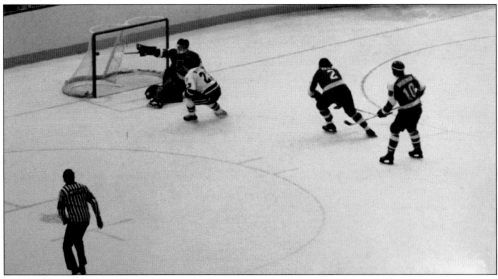

Bob Nystrom clinches the Islanders' first Stanley Cup with an overtime goal on May 24, 1980. A coliseum crowd of nearly 15,000 watched the Islanders squander a 4-2 lead in the third period, forcing a sudden-death session. At 7:11 of overtime, Nystrom redirected a pass behind Flyers goaltender Pete Peeters for a memorable 5-4 victory. (Photograph by Bruce Bennett; courtesy of Getty Images, Sport Collection.)

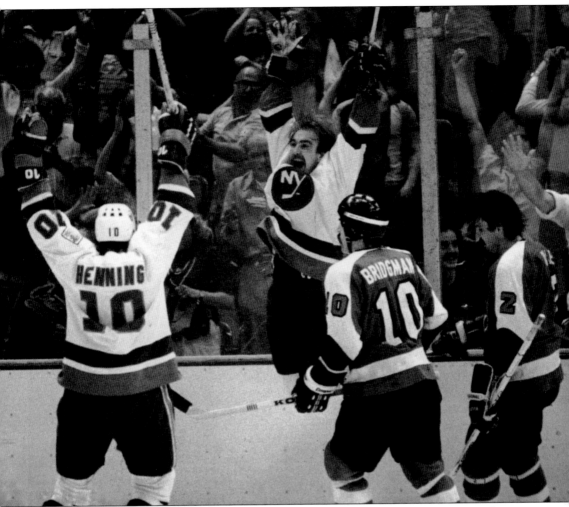

Seconds after securing the championship, Bob Nystrom (center) rejoices with teammate Lorne Henning and the coliseum faithful. Philadelphia captain Mel Bridgman and defenseman Bob Dailey skate away sullenly as the gleeful Islanders prepare to pile on Nystrom. Fans screamed and tossed confetti in the stands, while television crews rushed onto the ice. After being mobbed for half a minute, Nystrom wriggled free briefly before being sandwiched in a hug with Clark Gillies and Denis Potvin. The Islanders and Flyers then formed traditional handshake lines, drawing the scrappy series to a courteous close. New York set a finals record with 15 power-play goals and became only the second expansion team in NHL history to land professional hockey's highest honor. The Islanders also erased a choker label that followed the club's early play-off failures. (Photograph by Bruce Bennett; courtesy of Getty Images, Bruce Bennett Collection.)

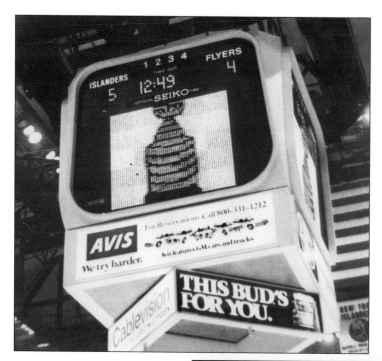

The coliseum scoreboard flashes the Stanley Cup to salute the Islanders' first title. It also bragged "Outcome Never in Doubt!!" as speakers played the Queen anthem "We Are the Champions." Elsewhere on Long Island, Suffolk County executive Peter Cohalan recalled a delicious bet. Philadelphia mayor William Green had promised Cohalan a basket of mustard pretzels if the Islanders prevailed, according to the *New York Times*. (Courtesy of Jackson B. Pokress.)

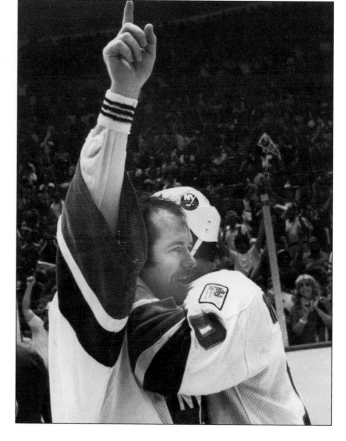

Billy Smith signals the Islanders' No. 1 rank while embracing Lorne Henning, who earned an assist on the game-winning goal. The Islanders became the first New York team to snag the Stanley Cup since the 1939–1940 Rangers. But Smith, who tied a play-off record for a goalie with 20 appearances, modified that distinction: "The Stanley Cup is not in New York. It's on Long Island." (Courtesy of Jackson B. Pokress.)

Islanders captain Denis Potvin parades the Stanley Cup around the coliseum ice as Butch Goring follows. Potvin, who scored six goals in the 1980 play-offs, won the Calder Trophy as NHL rookie of the year in 1974 and thrice gained the Norris Trophy as top defenseman. He was inducted into the Hockey Hall of Fame in 1991. (Photograph by Bruce Bennett; courtesy of Getty Images, Bruce Bennett Collection.)

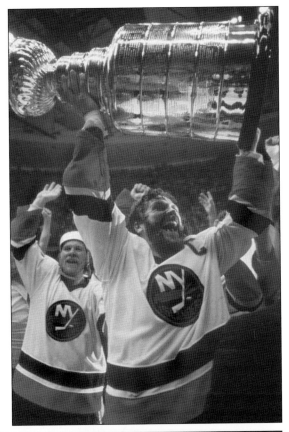

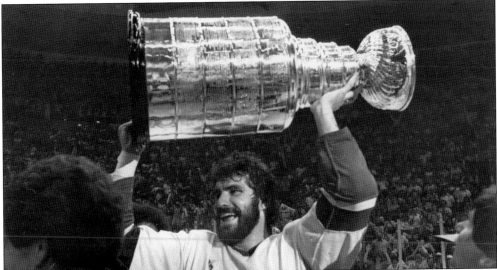

Clark Gillies, a scorer and enforcer for the Islanders, hoists the Stanley Cup. Denis Potvin, who enjoyed the first victory lap with the trophy as the team's captain, handed the silver chalice to Gillies, who previously wore the "C." Known as a physical aggressor on the "Trio Grande" line with Mike Bossy and Bryan Trottier, Gillies became a Hockey Hall of Famer in 2002. (Courtesy of Jackson B. Pokress.)

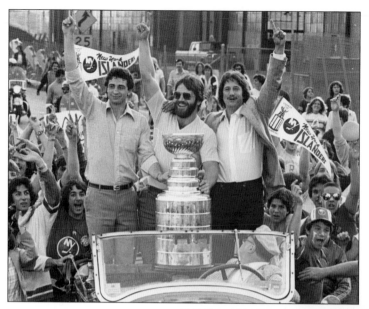

Four days after clinching the Stanley Cup, Denis Potvin (center) rides with right wing Duane Sutter (left) and center Steve Tambellini in a 1.5-mile parade from Garden City to the coliseum. Noise from the 30,000 fans lining the route grew so deafening that organizers canceled speeches outside the arena by coach Al Arbour, general manager Bill Torrey, and elected officials. (Courtesy of Jackson B. Pokress.)

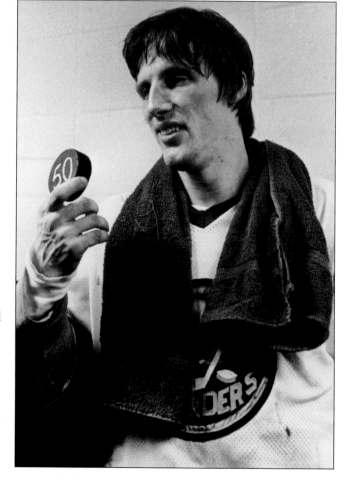

Mike Bossy displays the puck with which he scored his 50th goal in the first 50 games of the season on January 24, 1981. Bossy became the second NHL player to achieve the feat, joining Maurice "Rocket" Richard of the 1944–1945 Montreal Canadiens. The Islanders winger registered no shots in the first two periods but scored twice in the third. (Photograph by Bruce Bennett; courtesy of Getty Images, Sport Collection.)

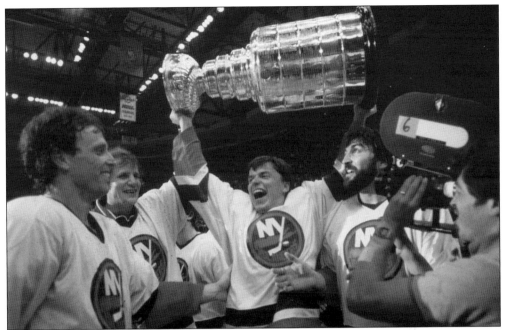

After the Islanders won a second consecutive championship, center Anders Kallur lifts the Stanley Cup on May 21, 1981. Also reveling at the coliseum are, from left to right, Wayne Merrick, Stefan Persson, and John Tonelli. Butch Goring, who netted two goals in the 5-1 clincher over the Minnesota North Stars, was named the postseason's most valuable player. (Photograph by Bruce Bennett; courtesy of Getty Images, Bruce Bennett Collection.)

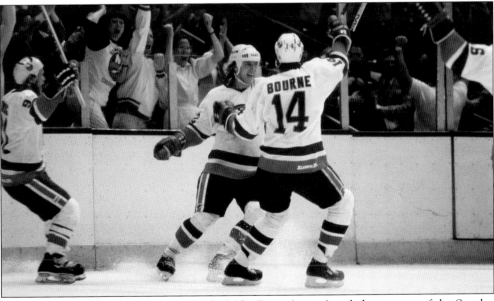

Fans cheer after an early-morning score by Mike Bossy (center) ended game one of the Stanley Cup finals on May 9, 1982. As plentiful penalties and an extended overtime pushed the game past midnight, Bossy completed a hat trick in the final seconds of the extra period. The Islanders swept the Vancouver Canucks to seize a third straight title. (Photograph by Bruce Bennett; courtesy of Getty Images, Sport Collection.)

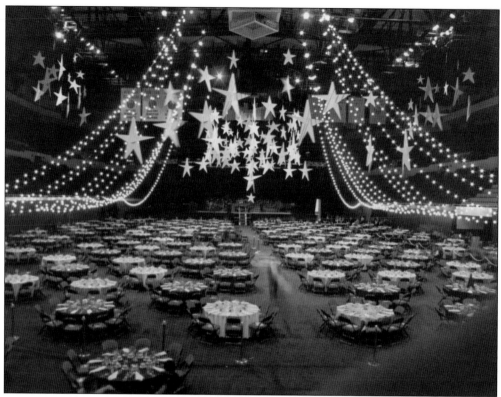

Strings of lights dangle from the coliseum rafters to decorate a benefit the night before the 1983 NHL All-Star Game. The $200-a-plate feast lured about 1,500 guests, according to the *Philadelphia Inquirer*, while thousands more paid $12.50 or $15 for just the post-dinner entertainment. The Juvenile Diabetes Foundation reaped proceeds from the event, featuring Canadian singer Anne Murray, comedian Billy Crystal, and disc jockey Don Imus. (Courtesy of Lance Elder.)

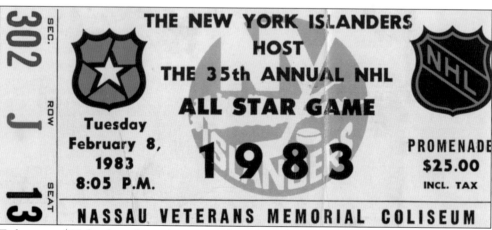

SEC. 302 ROW J SEAT 13

THE NEW YORK ISLANDERS
HOST
THE 35th ANNUAL NHL
ALL STAR GAME

Tuesday
February 8,
1983
8:05 P.M.

1983

PROMENADE
$25.00
INCL. TAX

NASSAU VETERANS MEMORIAL COLISEUM

Tickets cost $25 for the coliseum's promenade seats at the NHL All-Star Game on February 8, 1983. The hometown Islanders bragged four players representing the Prince of Wales Conference, later renamed the Eastern Conference. The quartet of Mike Bossy, Dave Langevin, Denis Potvin, and Bryan Trottier had a familiar coach. Al Arbour gained the right since he had helmed the Islanders to the conference crown the previous season. (Author's collection.)

Wayne Gretzky of the Edmonton Oilers smiles after notching his fourth goal for the Clarence Campbell Conference in the 1983 NHL All-Star Game. Gretzky's tallies broke the all-star record of three in a game, set in 1950 by Ted Lindsay, and sparked a 9-3 triumph over the Prince of Wales Conference. The 22-year-old sniper received a $14,000 sports car as the game's Most Valuable Player. (Courtesy of AP/Wide World Photographs.)

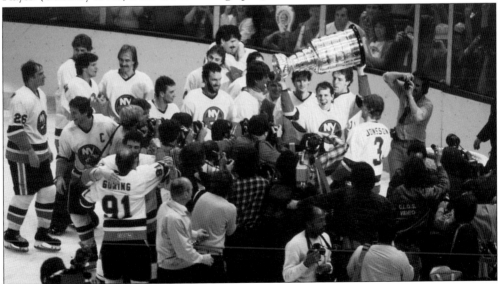

Treasuring a fourth consecutive title, Stefan Persson clutches the Stanley Cup on May 17, 1983. The Islanders' victory over the Edmonton Oilers marked only the third such streak of NHL championships, joining runs by the Montreal Canadiens in the late 1950s and late 1970s. Reporters often referred to the coliseum as "Fort Neverlose" during this era. (Photograph by Bruce Bennett; courtesy of Getty Images, Bruce Bennett Collection.)

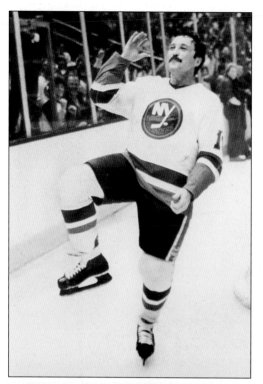

Bryan Trottier dances on the ice after the Islanders' Stanley Cup clincher in 1983. In the decisive game four, Trottier scored and helped neutralize Edmonton Oilers phenom Wayne Gretzky, who did not post a single goal in the finals sweep. During the celebration pictured here, Trottier also hugged Billy Smith, selected as the most valuable player of the postseason. (Photograph by Vincent Riehl; courtesy of the *New York Daily News*.)

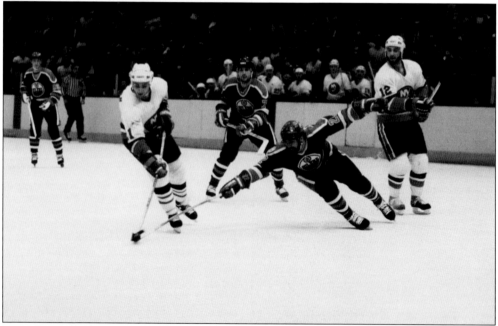

Brent Sutter (left) and his brother Duane skate against the Edmonton Oilers in the Stanley Cup finals in 1984. Following the play are, from left to right, Wayne Gretzky, Paul Coffey, and Charlie Huddy. Unlike the championship series in 1983, Gretzky produced this time. He scored twice during the game five win in Canada that ended the Islanders' reign. (Photograph by Focus On Sport; courtesy of Getty Images, Sport Collection.)

Bryan Trottier (left) solemnly pats Washington Capitals defenseman Rod Langway after the Islanders lost a first-round play-off series on April 12, 1986. The Islanders suffered two humiliating results for the first time in team history: an opening-round exit and a postseason sweep. Questions ensued about the club's aging stars. The roster transformed in subsequent seasons as dynasty-era mainstays gave way to a new generation. (Courtesy of Jackson B. Pokress.)

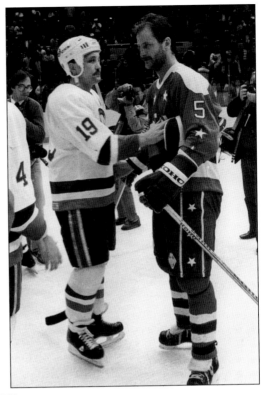

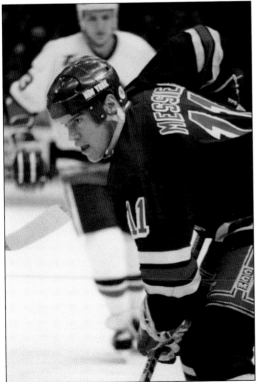

Few foes tormented the Islanders as consistently in the 1980s and 1990s as center Mark Messier, seen here awaiting a coliseum face-off. Messier helped the Edmonton Oilers overthrow the Islanders' dynasty in 1984 before being traded to another rival club, the New York Rangers, in 1991. A second Oilers great, Wayne Gretzky, joined the Blueshirts in 1996. Both men are enshrined in the Hockey Hall of Fame. (Courtesy of Rich Walker.)

Pictured above, referee Kerry Fraser oversees an Islanders-Rangers preseason tilt at the coliseum on September 14, 1991. The NHL relies on officials to drop the puck for face-offs, call icing and offside, and maintain order on the ice. They also stop play for injuries. Pictured below, referee Denis Morel waits for an Islanders trainer to aid fallen blueliner Jeff Norton during a Rangers clash on December 28, 1991. Leaning over Norton is Joe Reekie, who kept officials busy that night with penalties for unsportsmanlike conduct and roughing. Note the 20th anniversary patches on the players' shoulders. The Islanders won 5-4 behind goals from Ray Ferraro, Tom Fitzgerald, Benoit Hogue, Derek King, and Uwe Krupp. (Courtesy of Rich Walker.)

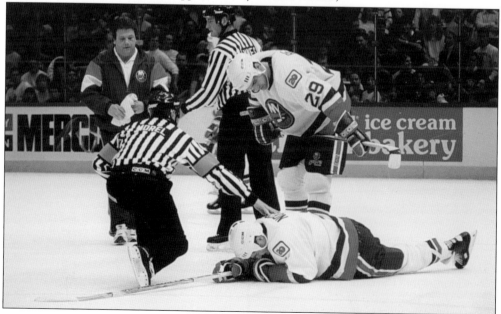

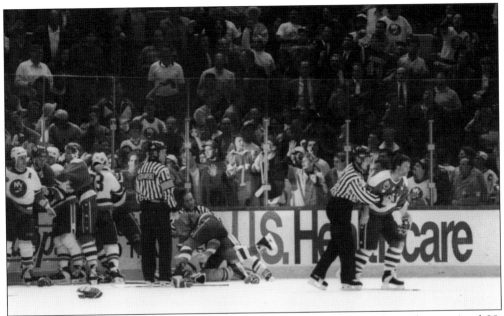

The Islanders brawl with the Washington Capitals after an infamous cheap shot on April 28, 1993. With Washington on the brink of a first-round play-off departure, the Capitals' Dale Hunter slammed Islanders superstar Pierre Turgeon into the boards following a New York goal. This photograph shows Hunter (far right) being escorted off the ice. He was suspended for 21 games. (Photograph by Bruce Bennett; courtesy of Getty Images, Sport Collection.)

An Islanders trainer escorts Pierre Turgeon to the locker room in the wake of the Dale Hunter hit in 1993. Turgeon, who notched 58 goals and 74 assists in the regular season, suffered a separated right shoulder. He returned for the Islanders' second-round clincher over the Pittsburgh Penguins and a losing effort versus Montreal in the conference finals. (Photograph by Bruce Bennett; courtesy of Getty Images, Sport Collection.)

Glenn Healy, who spent four seasons on Long Island in the early 1990s, mans the coliseum crease versus the Rangers. During the Islanders' unlikely march to the 1993 conference finals, the acrobatic Healy had nine postseason wins and played in all 18 play-off matches. The Islanders left Healy exposed in the 1993 expansion draft, however, and he was selected twice before being traded to the Rangers. (Courtesy of Rich Walker.)

The Islanders introduced their short-lived mascot, a seafaring fisherman named Nyisles (pronounced NIGH-ils), during the 1994–1995 season. With a giant helmet and flashing goal light atop his head, the shaggy-haired character was conceived to entertain fans and forge a marketable new look to contrast with the fading on-ice product. The maritime approach, later reinforced with a Gorton's Fisherman-like jersey logo, fell flat with many spectators. (Courtesy of Rich Walker.)

Zigmund Palffy wears the "A" as assistant captain during the Islanders' miserable 1996–1997 campaign. The team wallowed in last place for a third straight season, though Palffy buried a career-high 48 goals and defenseman Bryan Berard developed into the league's rookie of the year. The Islanders shipped Palffy to the Los Angeles Kings in an unpopular 1999 trade. (Photograph by Jim Leary; courtesy of Getty Images, Bruce Bennett Collection.)

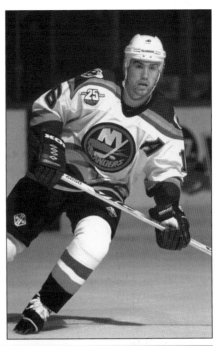

Dave Thomas (center) visits the coliseum to film commercials for the Wendy's fast-food chain in the late 1990s. In one spot, Thomas sported an orange-and-white NHL jersey—with the unassuming No. 00—as he chatted with Rangers goaltender Mike Richter and drove a Zamboni. Flanking Thomas in this image are Lance Elder (left), the arena's general manager, and Jim Wynkoop (right), the director of operations. (Courtesy of Lance Elder.)

Defenseman Kenny Jonsson fires a shot toward the Detroit Red Wings goal on November 25, 2000. The Islanders' 4-3 loss, their eighth in a row, served as a microcosm of lackluster finishes in Jonsson's first six seasons on the club. He was tapped as the team's captain in 1999 but stepped down days before this photograph was taken. (Photograph by Dennis Clark; courtesy of the *New York Daily News*.)

After the most memorable penalty shot in Islanders history, Shawn Bates exults with teammates Jason Blake (left) and Dave Scatchard on April 24, 2002. Facing the Toronto Maple Leafs in game four of the quarterfinals, Bates powered a 4-3 triumph by shooting the puck over Curtis Joseph's stick with just 2:30 left in regulation. The dramatic victory knotted the series. (Photograph by Al Bello; courtesy of Getty Images, Sport Collection.)

Islanders pugilist Eric Cairns skates off the coliseum ice after pummeling the Maple Leafs' Shayne Corson in the 2002 quarterfinals. In the game six bout on April 28, Cairns connected on several consecutive rights to knock down Corson, seen in the background. New York's Mariusz Czerkawski netted two goals in the 5-3 win, but the Islanders lost the series clincher in Canada two days later. (Courtesy of AP/Wide World Photographs.)

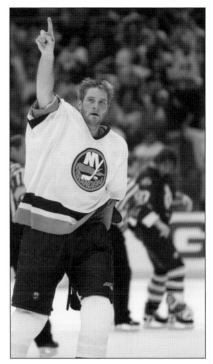

A man masked as Pres. Barack Obama pleads for the Islanders to select John Tavares with the No. 1 pick in the 2009 draft. About 10,000 fans journeyed to a coliseum party to watch live television coverage of the amateur selections in Montreal. The crowd erupted when Islanders general manager Garth Snow picked Tavares, an 18-year-old center with 215 career goals in the Ontario Hockey League. (Photograph by the author.)

Pittsburgh Penguins captain Sidney Crosby (left) and Islanders assistant captain Brendan Witt pose for the ceremonial opening face-off at New York's opener on October 3, 2009. Nassau County executive Tom Suozzi, a proponent of the Lighthouse project to renovate the coliseum, prepares to drop the puck. Beside Suozzi, from left to right, stand Islanders owner Charles Wang and Hockey Hall of Famers Bryan Trottier and Mike Bossy. (Photograph by the author.)

Just months after the 2009 draft, John Tavares drops to one knee to celebrate his first NHL goal. In the second period of the Islanders' October 3 opener, Tavares backhanded the puck past Penguins keeper Marc-Andre Fleury, skated to the boards, and embraced his teammates. New York lost, 4-3, but the franchise's supposed savior offered hope to the coliseum faithful. (Photograph by Bruce Bennett; courtesy of Getty Images, Sport Collection.)

Four

A Smokin'
Sports Palace

Construction debris littered the coliseum during a 1971 tour by the world heavyweight champion. Joe Frazier, donning a suit and a hard hat, followed Nassau County executive Ralph Caso to the center of the unfinished arena. Months earlier, Frazier had defeated Muhammad Ali in the "Fight of the Century" at Madison Square Garden. Now he considered a rematch on Long Island. The *New York Times* recorded his assessment: "I wouldn't mind having my next fight with Ali here."

Those widely reported words turned into a cherished marketing tool. Frazier had legitimized the coliseum as a big-time venue while recognizing its athletic possibilities beyond the Nets and Islanders. When the arena hosted an open house in spring 1972, Frazier returned to present Caso with a gold-plated boxing glove, an expression of his continuing desire to fight there. Soon after, the county published his photograph in an advertising supplement that heralded the coliseum. An accompanying article plugged the flexibility for "almost any kind of sporting event," from roller derby and wrestling to bicycle races and tennis.

Such boasts prefaced bookings. Challenging Madison Square Garden's grip on college basketball, the coliseum planned the inaugural Nassau Classic tournament for December 1972, luring Hofstra University, Jacksonville, Long Beach State, and Oral Roberts. Later that season, Notre Dame faced St. John's in a televised game from Uniondale, overshadowing a simultaneous college game in Manhattan. Besides hoops, the coliseum also snared the Knights of Columbus track meet in 1973, after its organizers became discouraged with dwindling attendance on Eighth Avenue.

For all the events the coliseum landed, however, one remained elusive. The Ali-Frazier rematch went to the Garden in 1974, while the boxers' third bout occurred in the Philippines in 1975. A rumored spat between Frazier and Floyd Patterson never materialized on Long Island either. In fact, Frazier did not enter the Uniondale ring until 1976, when he had clearly passed his prime.

Still Frazier's early approval of the arena seemed to bless its tenants. Given Long Island's rank among the nation's most populated areas and its residents' eye-popping incomes, the county predicted teams flocking to the coliseum. What officials could not have expected, however, was how often those clubs, like "Smokin' Joe," would become champions.

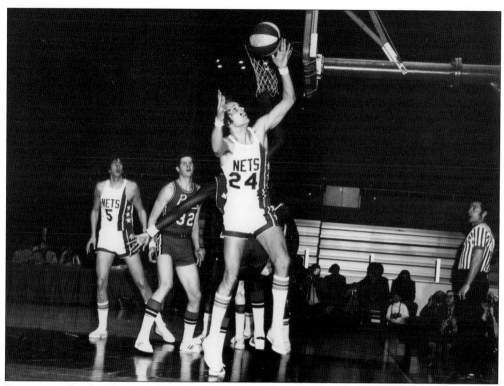

During a night the Nets clinched a play-off spot on March 15, 1972, Rick Barry craves the ball in a 119-112 romp over the Memphis Pros. Barry scored 43 points, including 20 in the fourth quarter, in New York's 12th game and ninth victory at the coliseum. Pictured below, a Nets water boy offers nourishment to the bench, including Bill Melchionni (seated second from left), who had 28 points. In the postseason, the Nets edged the Kentucky Colonels and Virginia Squires to set up a finals showdown with the Indiana Pacers. The coliseum's first brush with glory ended with New York falling to Indiana in six games. (Courtesy of the Queens Borough Public Library, Long Island Division, Joseph A. Ullman Photographs.)

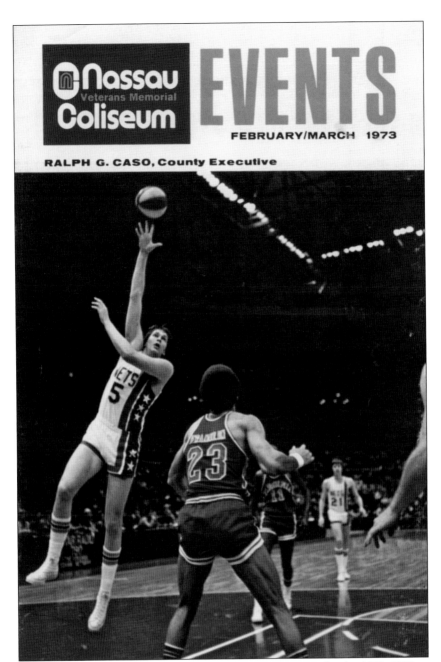

Former St. John's star Billy Paultz emerged as the Nets' go-to scorer for the 1972–1973 campaign. Meshing all-star skills with community involvement, Paultz appeared at the team's basketball clinics and co-owned a restaurant near the coliseum. He also averaged 16.7 points per game as the Nets earned another play-off berth. Depicting Paultz as the face of the franchise, this events calendar shows the standout center in action versus the Virginia Squires. He excelled in the first-round series against the Carolina Cougars, scoring a game-high 26 points in the opener. But the Nets could not match Carolina, which led the division for every day of the regular season. New York fell in five games, ending the tenure of coach Lou Carnesecca, who departed to helm Paultz's alma mater at St. John's. (Courtesy of Lance Elder.)

The coliseum's track, seen in this rare image, debuted inauspiciously for a Knights of Columbus meet on January 13, 1973. The morning of the event, arena workers discovered the track pieces did not create an oval when fitted together, so they cut out a section and re-marked the starting lines and relay zones. The *New York Times* reported that the track also lacked a mandated raised border, meaning any records set at the coliseum might not stand. Another snag arose during the event, when two floor sections became separated by a potentially hazardous 1-inch crevice. Carpenters delayed the meet to fix the crack. Those drawbacks, however, did not negate the drama of the night. A crowd of 8,551 watched the 1,000-meter run won by Byron Dyce, an Olympian from Jamaica. Among the high-quality competitors in the 60-yard dash was Dr. Delano Meriwether, a hematologist known for unconventional training methods and unusual attire. He often ran backwards up the stairs in his apartment building and once wore suspenders and swim trunks in a race. (Courtesy of Lance Elder.)

Clayton Moore reprised his television role as the Lone Ranger for the coliseum's western spectacular in September 1973. Clowns and country music joined the masked hero as part of Stoney Burke's World Championship Rodeo. Spanning five performances in three days, the attraction also promised nearly 200 cowboys and cowgirls competing for $10,000 in prize money. The rodeo's title referred to a short-lived television western starring Jack Lord, who continued making appearances as the rider from the show. Similarly Moore portrayed the Lone Ranger at multiple events, resulting in a legal battle in 1979. A company that bought the rights to the character sued Moore, fearing he might undercut its promotional efforts for an upcoming movie. An injunction temporarily barred Moore from wearing Kemo Sabe's signature mask, but he eventually regained the right. (Courtesy of Lance Elder.)

Rowdy fans tear the netting from a basket after the Nets clinched the team's first title on May 10, 1974. Pictured below, New York superstar Julius "Dr. J" Erving wears his jersey inside out while chugging champagne in the coliseum locker room. Erving, in his first season with the Nets, led the club to the championship with help from Billy Paultz and rookie Larry Kenon. New York went 55-29, rolled over the Virginia Squires in the first round, and swept the Kentucky Colonels in the eastern division finals. The Nets clinched the crown with a 111-100 victory over the Utah Stars in Uniondale. (Photographs by Dan Farrell; courtesy of the *New York Daily News*.)

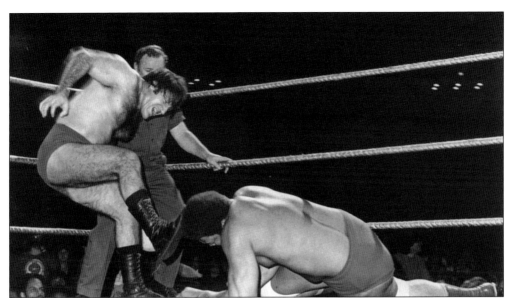

Bruno Sammartino (left) meets Ernie Ladd in the coliseum ring on December 29, 1975. Sammartino, who emigrated from Italy as a teenager, ruled the World Wide Wrestling Federation as champion from 1963 to 1971 and from 1973 to 1977. Ladd, meanwhile, starred as a defensive tackle with the AFL's San Diego Chargers in the 1960s. He wrestled during and after his football career. (Courtesy of *Pro Wrestling Illustrated*.)

NEW YORK SETS

Billie Jean King Virginia Wade

1975 SEASON TICKET PLAN

An eyebrow-raising league named World Team Tennis plopped its New York franchise at the coliseum in 1974. Locals soon warmed to the Sets. This brochure shows Billie Jean King (left) and Virginia Wade, who led the club to the 1976 championship. The Sets became the Apples in 1977 and added home dates at the Felt Forum and Madison Square Garden. They eliminated Uniondale the following year. (Courtesy of Lance Elder.)

Now for the first time

YOU CAN WATCH

LACROSSE

PLAYED BY THE

1974 WORLD'S CHAMPIONSHIP PRO LACROSSE TEAM

THE LONG ISLAND TOMAHAWKS

AT THE

nassau Veterans **n** Memorial **Coliseum**
EXIT M4 FROM MEADOWBROOK PARKWAY HEMPSTEAD TURNPIKE UNIONDALE N.Y. 11553

1975 SEASON TICKET INFORMATION ➤

A year after the New York Sets introduced tennis at the coliseum, the Long Island Tomahawks unveiled box lacrosse in 1975. Playing in the metropolitan area marked progress for the National Lacrosse League, as the six-team operation entered its second year. The league moved the Rochester Griffins, champions in the inaugural 1974 season, to the lacrosse hotbed of Long Island. Several factors seemed to favor the financial success of the relocated club. Most notably, the league hoped to capitalize on the popularity of outdoor lacrosse and Islanders hockey in the region. This brochure, for example, noted the similarities between the NLL and NHL, including the rink dimensions and six-man teams. One sentence condensed the sales pitch: "Be with us for our first season—we'll guarantee you a combination of bone-crunching, fast-moving action and excitement." The Tomahawks also boasted a wealthy owner, Bruce Norris, who controlled the NHL's Detroit Red Wings. In January 1975, a *New York Times* reporter asked Norris why he believed lacrosse would lure fans to Uniondale. "Because it's violent," he answered. (Courtesy of Lance Elder.)

Tomahawks teammates (left) sprint during a 1975 game versus the Maryland Arrows. Earlier that season, the Tomahawks debuted in Uniondale with a 14-13 loss to the Montreal Quebecois. The April 30 home opener attracted 7,328 spectators, and the fans soon learned the dangers of lacrosse. Quebecois goalie Dave Evans left in the second period after a ball struck his Adam's apple. (Courtesy of Lance Elder.)

HAPPINESS IS WINNING THE 1975 NATIONAL LACROSSE LEAGUE CHAMPIONSHIP

... AND WITHOUT YOUR SUPPORT, WE COULDN'T HAVE DONE IT!

ALL OF US IN THE TOMAHAWK ORGANIZATION THANK YOU.

THE LONG ISLAND TOMAHAWKS — 1975 NATIONAL LACROSSE LEAGUE CHAMPIONS

TOP ROW: L-R BRUCE TODMAN, KEVIN BARRETT, CHUCK MEDHURST, TED GREVES, ART SEEKAMP, AL LEWTHWAITE, LARRY McCORMICK, LEN POWERS, DOUG HAYES AND PAUL WARDEN.
MIDDLE ROW: L-R JOE MERAGLIA (Stickboy) HOWARD BALZER (Director of Public Relations), JOE MALLEY (Assistant Trainer), BILL HOCULIK, ART TALSON, JAN MAGEE, BARRY BARTLETT, PAUL MURDOCK, BILL TIERNEY, CHARLIE HENDERSON, GLEN NEUMAN, RAY ROSTAN (Assistant Public Relations), RON DUGUETTE (Communications Manager).
BOTTOM ROW: L-R PAUL MALLEY (Stickboy), MERV MARSHALL, RON FINUCAN (Business Manager), AL GORDANEER, BILL FOOTE, MORLEY KELLS (Coach and General Manager), BRIAN KEEGAN, JIM McCAFFREY (President), DAVE WILFONG, GARY VAN SCHAGEN, TIM BARRIE, IRENE SCHARF (Secretary), PEGGY SCHWALM (Secretary), MATT DRAFFEN (Stickboy).
MISSING: JIM JOHNSTON, BRUCE NORRIS (Owner)

A team photograph mistakenly identifies the 1975 Tomahawks as champions. In reality, the team bowed out to the Quebec Caribous in the first round of the play-offs. The NLL folded before the 1976 season, and the Tomahawks disbanded. In this image, the league's leading scorer, Doug Hayes, stands second from the right in the third row. He posted 104 goals in the regular season. (Courtesy of Lance Elder.)

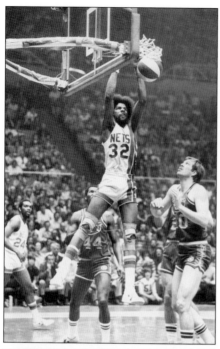

The Nets' Julius Erving dunks in the last-ever game of the American Basketball Association on May 13, 1976. New York defeated the Denver Nuggets in six contests to capture the league's final crown before the ABA merged with the National Basketball Association. The Nets played one NBA season in Uniondale, then moved to New Jersey for the 1977–1978 campaign. (Photograph by Dan Farrell; courtesy of the *New York Daily News*.)

Boxer George Foreman (far left) exchanges stares with Joe Frazier (far right) at the coliseum weigh-in three days before their bout on June 15, 1976. Sportscaster Howard Cosell, meanwhile, stands between sparring trainers Gil Clancy, to Cosell's right, and Eddie Futch. Frazier, 32, fell to Foreman, 27, in a fifth-round technical knockout. The heavily promoted match, billed as the "Battle of the Gladiators," drew 10,341 fans. (Courtesy of AP/Wide World Photographs.)

Spiros Arion (left) prepares to scrap with Bob Backlund at the coliseum on August 11, 1978. Arion, a member of championship tag teams in 1966 and 1967, lost to Backlund, who had secured the World Wide Wrestling Federation heavyweight belt in February. Decades later in 2000, Backlund waged an unsuccessful Republican campaign for a congressional seat in Connecticut. (Courtesy of *Pro Wrestling Illustrated*.)

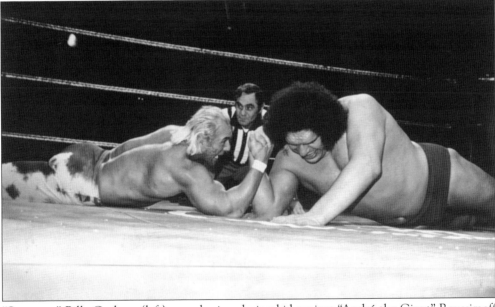

"Superstar" Billy Graham (left) grapples in a losing bid against "André the Giant" Roussimoff in the coliseum ring on November 17, 1978. Graham captured the WWWF heavyweight crown in 1977, while Roussimoff became a champion in 1988. The 7-foot, 4-inch, 520-pound French immigrant also won acclaim as a lovable giant in the Rob Reiner film *The Princess Bride* in 1987. (Courtesy of *Pro Wrestling Illustrated*.)

Baseball great Pete Rose kicks the ceremonial first ball before the inaugural match of the Major Indoor Soccer League on December 22, 1978. Rose, a co-owner of the MISL's Cincinnati Kids, stands before the Kids' first opponent and the coliseum's new tenant, the New York Arrows. The upstart league hoped to add more scoring to the sport by enlarging the goals to 6.5 feet high and 12 feet wide. Organizers also conceived a flashy "rocket red ball" to contrast with the emerald green playing surface. With the carpet laid over the Islanders' rink in Uniondale, the Arrows beat the Kids 7-2. New York's Jim Pollihan scored the first goal in league history while teammate Steve Zungul netted four more. A crowd of 10,386 also cheered Arrows goalie Shep Messing, who turned aside a flurry of shots in the third quarter. The team soon became a fixture on Long Island. The Arrows initially secured a nearby school gym for drills and later converted a Mitchel Field hangar into a practice field. (Courtesy of AP/Wide World Photographs.)

Shep Messing, a two-time All-American goalkeeper at Harvard University, became the MISL's first player when the Arrows signed him in 1978. Along with Steve Zungul, the aggressive Messing quickly emerged among the league's most accomplished stars. He captured play-off MVP honors in 1979 and rose to interim coach in 1983 when the Arrows fired Don Popovic, the only man to ever helm the franchise. (Courtesy of Robert L. Harrison.)

#1 Shep Messing

Goalkeeper

Height: 6'0"
Weight: 175 lbs.
Born: October 9, 1949

#7 Steve Zungul

Forward

Height: 6'0"
Weight: 170 lbs.
Born: July 28, 1954

Yugoslav striker Steve Zungul, nicknamed the "Lord of All Indoors," epitomized the Arrows' dominance through the MISL's early years. After notching a hat trick in the league's first-ever game in 1978, Zungul finished with 43 goals in 18 games that season, earning an all-star nod and leading the Arrows to their first title. He totaled a career-high 108 goals for the Arrows in the 1980–1981 campaign. (Courtesy of Robert L. Harrison.)

1978-1979 LEAGUE CHAMPIONS

Front Row (left to right): Renato Cila, Luis Alberto, Damir Sutevski, Coach Don Popovic, Shep Messing, Enzo DiPede, Peter Duerden, Steve Zungul, Branko Segota.
Back Row (left to right): Alex Inotay Trainer, Jim McLoughlin, Jim Pollihan, John Nusum, Hugh Creaney, Ibraim Silva, Pat Ercoli, Carl Rose, Craig Reynolds, Doug Pollard.

The Arrows blossomed into champions in the league's inaugural season. In a one-game semifinal versus the Cincinnati Kids at the coliseum, New York's Steve Zungul scored five goals en route to a 9-4 triumph. Zungul starred again in the first-ever MISL finals against the Philadelphia Fever, with 10 goals in two games, as the Arrows commenced a commanding four-year reign over the league. (Courtesy of Robert L. Harrison.)

Bruno Sammartino winds up a punch in his victory over Jerry Valiant at the coliseum on June 16, 1979. Valiant won the tag team title with his stage brother, Johnny, just months before this match. A third story line sibling, Jimmy, defeated Steve Travis in Uniondale the day this photograph was taken. The WWE honored Jimmy and Johnny with a Hall of Fame induction in 1996. (Courtesy of *Pro Wrestling Illustrated*.)

Original Arrow Luis Alberto, seen here celebrating with a teammate, set up many crucial goals with his precise passes. The Argentinian forward assisted on Steve Zungul's game-winning score against the St. Louis Steamers in the 1981 championship game, securing New York's third straight MISL title. The Arrows sold Alberto to the Cleveland Force in 1982, months before clinching their fourth and final league crown. (Courtesy of Robert L. Harrison.)

Jimmy Snuka (front) tries to wiggle his arm free from Bob Backlund's grasp during a Texas Death Match on September 4, 1982. Under this extremely dangerous format with no time limits or disqualifications, a bout concludes only when a wrestler can no longer continue. Snuka, who feuded often with Backlund, popularized the "Superfly Splash" move of jumping on an opponent from the top rope. (Courtesy of *Pro Wrestling Illustrated*.)

JOE ULRICH

Defender Joe Ulrich joined the Arrows in 1983 after an outstanding collegiate career at Duke University, where he won the 1982 Hermann Trophy as the NCAA's player of the year. Inking Ulrich to a two-year, $56,000 pact signaled an effort to boost attendance at the coliseum with American draws. New York traded Steve Zungul just days after signing Ulrich. (Courtesy of Robert L. Harrison.)

Michael Collins, a brash midfielder born in Hicksville, Long Island, scored 22 goals with 28 assists over three seasons with the Arrows, from 1981 through 1984, when the team disbanded. He also played for the Arrows' successor at the coliseum, the New York Express, in that club's only season in 1986–1987. Collins represented New York in the 1987 MISL All-Star Game with defender Chris Whyte. (Courtesy of Robert L. Harrison.)

MICHAEL COLLINS

Ivan Putski (on top), seen here overpowering "Cowboy" Bob Orton, engaged in a 30-man Battle Royal in Uniondale on December 27, 1985. The Junkyard Dog and Terry Funk shared a $75,000 prize by outlasting Putski, Orton, Bret Hart, the Iron Sheik, and two dozen others. Putski, who competed in the 1978 Strongest Man Competition, regularly squeezed competitors in headlocks with his massive arms. (Courtesy of *Pro Wrestling Illustrated*.)

The Arrows disbanded in July 1984 amid sagging attendance at the coliseum. Two years later, the New York Express arrived in Uniondale for the 1986–1987 MISL season. Former Arrows standout Shep Messing returned to the arena as an Express co-owner and netminder. Still the hastily assembled squad struggled to a 3-23 start and folded in February 1987, leaving behind mementos like this souvenir card. (Courtesy of Robert L. Harrison.)

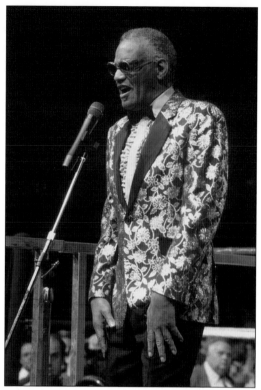

The World Wrestling Federation, under the direction of its bold promoter Vince McMahon, generated unprecedented buzz for its second annual spectacle, WrestleMania 2, on April 7, 1986. Hoping to build on the success of his inaugural extravaganza, McMahon arranged for pay-per-view hook-ups from three venues: the coliseum, the Los Angeles Memorial Sports Arena, and the Rosemont Horizon in Illinois. Besides heavily promoted matches, the WWF's publicity efforts billed celebrities who would play various roles at each arena. Pictured at left, Ray Charles sings "America the Beautiful" at the coliseum to kick off the event. Below, frequent *Tonight Show* act Joan Rivers serves as a guest ring announcer. McMahon provided coliseum commentary with Susan Saint James of the television shows *McMillan and Wife* and *Kate and Allie*. (© 1986 World Wrestling Entertainment, Inc. All Rights Reserved.)

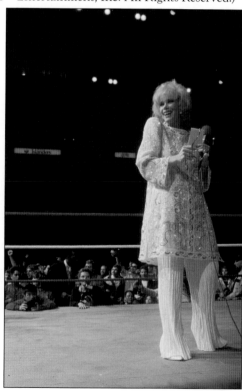

"Macho Man" Randy Savage guides George "The Animal" Steele into the ring during their WrestleMania 2 clash for the intercontinental heavyweight championship. Earlier, the 288-pound Steele chomped on his opponent's calf and arm, then bashed him with a bouquet of flowers. He became distracted, though, by Savage's gorgeous manager, Miss Elizabeth, allowing Savage to recover and retain his belt. (© 1986 World Wrestling Entertainment, Inc. All Rights Reserved.)

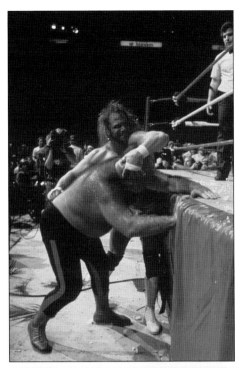

The coliseum portion of WrestleMania 2 culminated with a boxing spat between Mr. T and "Rowdy" Roddy Piper. The WWF booked three celebrity judges: jazz singer Cab Calloway, New Jersey Nets star Darryl Dawkins, and Watergate operative G. Gordon Liddy. Pictured here, Liddy (left) chats with Piper. Keeping time for the match was the actor from Burger King's memorable "Herb" commercials. (© 1986 World Wrestling Entertainment, Inc. All Rights Reserved.)

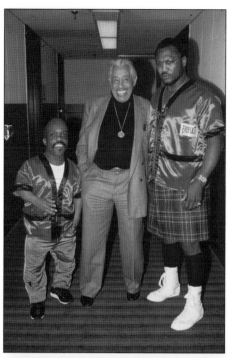

Mr. T prepared for the match with wrestler Raymond Kessler, nicknamed the Haiti Kid, and legendary boxer Joe Frazier. As the pair offered rubs of encouragement before the contest, Mr. T told the cameras he knew Piper would "be getting hurt out there." This photograph shows celebrity judge Cab Calloway (center) posing with Kessler and Frazier. (© 1986 World Wrestling Entertainment, Inc. All Rights Reserved.)

"Rowdy" Roddy Piper (center) forms a fist alongside his WrestleMania 2 trainer, Lou Duva (left), and corner man "Cowboy" Bob Orton. Duva, an Olympic gold medal boxing coach, called Piper "the best prospect going" during the telecast. Piper, meanwhile, pledged to quit boxing and wrestling, as well as "tiddlywinks" and "dating girls," if Mr. T knocked him out. (© 1986 World Wrestling Entertainment, Inc. All Rights Reserved.)

Following weeks of back-and-forth rhetoric, "Rowdy" Roddy Piper (left) faces Mr. T at WrestleMania 2. Referee Jack Lutz (in background) offered pre-bout instructions to the pair, but Piper kept inciting Mr. T until the boxers had to be separated by their trainers. Moments later, the bell rang to begin the fight. Piper employed dirty tactics. In the first round, he continued punching Mr. T as Lutz pulled them apart. In the second, Piper knocked down his opponent, then kicked him. Piper was eventually disqualified in the fourth round after shoving Lutz to the canvas and bodyslamming Mr. T. In a post-match interview with promoter Vince McMahon and celebrity commentator Susan Saint James, Piper accused Lutz of "sticking his nose in my business." McMahon, meanwhile, scolded Piper for conduct that was "less than becoming." (© 1986 World Wrestling Entertainment, Inc. All Rights Reserved.)

To transform the World Wrestling Federation into a global phenomenon, owner Vince McMahon sought a flamboyant superstar who could exhilarate audiences across the nation. Terry Bollea fit the role. In the 1980s, the little-known Bollea transformed into the widely popular Hulk Hogan, a charismatic hero who referred to his biceps as "24-inch pythons." Hogan's all-American persona landed him a role in *Rocky III* and an appearance on MTV. During the Hulkamania craze, hawkers billed Hogan T-shirts, hats, dolls, and headbands. His bronzed form became a headline attraction for WWF matches. Hogan, seen here in his trademark bandana, goads the coliseum crowd to roar during his triumph over the Earthquake on February 16, 1991. Hogan later starred in the VH1 reality show *Hogan Knows Best*, which followed his interactions with his wife, Linda, and children Brooke and Nick. (© 1991 World Wrestling Entertainment, Inc. All Rights Reserved.)

After the Long Island Tomahawks disbanded in 1976, the coliseum went without a lacrosse club until the New York Saints' entry in 1989. The franchise played the previous two seasons in the Meadowlands, winning the 1988 championship. That success, however, did not initially transfer to Uniondale. The Saints lost to the Baltimore Thunder on January 20 in the coliseum's first-ever Major Indoor Lacrosse League game. (Courtesy of Lance Elder.)

YOU, THE FAN, ARE THE SEVENTH MAN !

BE A PART OF THE HOME FIELD ADVANTAGE!

NEW YORK SAINTS

Photos: Bruce Bennett

MAJOR INDOOR LACROSSE LEAGUE
at the

Nassau Veterans Memorial Coliseum

DON'T MISS A SECOND OF HIGH SCORING RAZOR'S EDGE EXCITEMENT

HOME SCHEDULE			AWAY SCHEDULE		
Fri, Jan 12	8:00 PM	Philadelphia	Sat, Jan 13	8:00 PM	New England
Sat, Feb 3	8:00 PM	New England	Sun, Jan 21	2:00 PM	Baltimore
Sat, Feb 17	8:00 PM	Pittsburgh	Sat, Mar 3	8:00 PM	Detroit
Sat, Mar 17	8:00 PM	Baltimore	Sat, Mar 24	8:00 PM	Philadelphia

Game:_____ Price:_____

Contact:_____

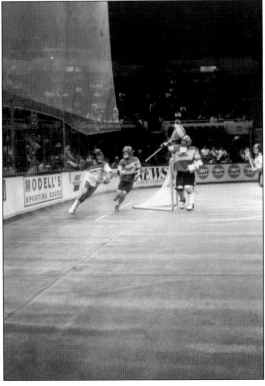

A New York Saints attacker carries the ball by the net of the Baltimore Thunder. In the Saints' inaugural coliseum season in 1989, the team finished 6-2 before losing a tight championship game. The club made the play-offs five times in the 1990s without landing a title, then missed the postseason for six straight years. New York became an inactive franchise after the 2002–2003 season. (Courtesy of Rich Walker.)

The American Gladiators tour, based on the television show featuring displays of strength, rumbled into the coliseum on October 20, 1991. Pictured above, female competitors wield heavily padded pugil sticks in an aggressive event called "The Joust." Each helmet-clad player stood on a small platform and tried to knock off her opponent with the weapon. Rules barred grabbing a challenger's stick and using one's hands to push them, among other infractions. Pictured below, bodybuilder Jim Starr—known to audiences as "Laser"—signs autographs for fans. The muscle-bound actor had the longest run of any of the show's on-air talent besides host Mike Adamle. The cult series ran from 1989 to 1996, with a remake premiering in 2008. (Courtesy of Rich Walker.)

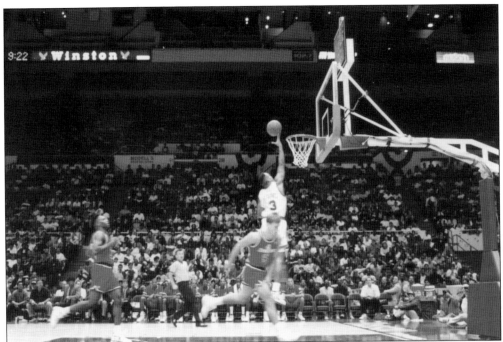

Professional basketball continued at the coliseum after the Nets' departure, as the Knicks stopped by for occasional preseason matches. Pictured here, John Starks attempts a basket en route to a 112-91 clubbing of the Washington Bullets on October 13, 1991. Starks had 14 points, as did Patrick Ewing, while Mark Jackson added eight for first-year Knicks coach Pat Riley. Larry Stewart led the Bullets with 23. (Courtesy of Rich Walker.)

While relying on Hulk Hogan, the World Wrestling Federation also stressed rivalries to stir the audience. Many feuds developed when a good-guy grappler "turned heel," assuming a villainous role. Brothers Bret and Owen Hart, for example, became enemies after Owen's bad-boy shift. Pictured here, Owen (left) and Bret scrap at the coliseum on July 9, 1994. (© 1994 World Wrestling Entertainment, Inc. All Rights Reserved.)

Roller Hockey International glided into the coliseum during the 1996 season. Long Island's newest team adopted the nickname Jawz, a reference to the great white shark from the 1975 movie. Advertisements compared the club and the film: "It's summer fun for the whole family with chills, thrills, excitement and entertainment . . . *without* the terror." For its logo, the team chose a shark with a stick, gloves, and inline skates—a cartoonish choice as part of a kids-oriented marketing effort. The Jawz also compiled a superb roster ahead of the June 7 opener versus the Minnesota Arctic Blast. Many players had backgrounds in professional ice hockey. In this photograph, Long Island scorer Hugo Belanger shoots on Orlando Jackals netminder Mark Reimer. Belanger, who was drafted by the NHL's Chicago Blackhawks, led the Jawz with 48 goals and 53 assists. Another contributor, Glen Metropolit, potted 32 tallies before embarking on a career as an NHL journeyman. The Jawz finished 16-9-3 but missed the play-offs in the club's only season. (Photograph by Jim McIsaac; courtesy of Getty Images, Bruce Bennett Collection.)

The coliseum's V-shaped theme tower bills the 1998 Goodwill Games. Founded by media mogul Ted Turner, the international sports competition started in 1986 after cold war tensions led to Olympics boycotts by the United States in 1980 and by the Soviet Union in 1984. At right, Michelle Kwan dazzles the coliseum crowd, including former president Jimmy Carter, with her free skate routine on August 1. Donning a powder blue dress, Kwan fell while attempting a triple loop but recovered to land the gold medal. It was not, however, the story of the games. The previous week, 17-year-old Chinese gymnast Sang Lan landed on her head during a warm-up vault at the coliseum that left her partially paralyzed. The Goodwill Games were discontinued in 2001. (Above, courtesy of Rich Walker; right, courtesy of AP/Wide World Photographs.)

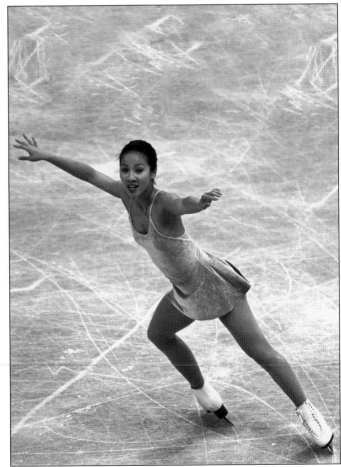

The Iowa Barnstormers of the Arena Football League headed east for the 2001 season. Renamed the New York Dragons, the team went 8-6 in its inaugural coliseum campaign before losing in the first round of the play-offs. Dragons quarterback Aaron Garcia, seen in this image, was named the league's top offensive player. The club last played in 2008. (Photograph by Jim McIsaac; courtesy of Getty Images, Sport Collection.)

Dwayne "The Rock" Johnson (right) pounds Brock Lesnar to the coliseum canvas at WWE's SummerSlam on August 25, 2002. Johnson employed his signature "Rock Bottom" move, pictured here, after driving Lesnar's manager, Paul Heyman, through an announcer's table. Lesnar countered by carrying Johnson on his shoulders and dropping him. The 25-year-old Lesnar won this match to capture the championship. (© 2002 World Wrestling Entertainment, Inc. All Rights Reserved.)

WWE star John Cena exults during a "parking lot brawl" at the Great American Bash on July 20, 2008. In the annals of the coliseum, Cena stuffed his challenger, John "Bradshaw" Layfield, into the front seat of this Ford Taurus. Cena then carried the car via forklift to the stage. Layfield eventually won by pinning Cena to the windshield. (© 2008 World Wrestling Entertainment, Inc. All Rights Reserved.)

Following the demises of the Tomahawks and Saints, a third lacrosse team developed a different approach when entering the arena in 2007. The New York Titans announced an inaugural home schedule split between the coliseum and its main competitor, Madison Square Garden. Pictured here, Titans captain Casey Powell (left) charges past Jack Reid of the Rochester Knighthawks on March 24. Rochester triumphed in the Titans' third Uniondale game. (Courtesy of Joseph O'Rourke.)

The Titans (left) line up for the national anthem before losing to the San Jose Stealth on February 24, 2007. New York's team logo, seen in the center circle, featured an armored helmet with the letter "T" in the face opening. When the franchise unveiled its decal in 2006, league officials emphasized home dates at Madison Square Garden, where the National Lacrosse League hoped to showcase its sport on a grand stage. Titans president George Daniel also stressed the allure of playing in "the heart of lacrosse country on Long Island." The team, however, struggled through its inaugural season, finishing in last place with a 4-12 record. The next year, the Titans cut out the coliseum and played all home games in Manhattan. The franchise moved to Orlando for the 2010 campaign. (Courtesy of Joseph O'Rourke.)

Calls for a renovated coliseum reached a critical juncture in 2004 when Islanders owner Charles Wang unveiled his vision. Wang's proposed redevelopment called for a coliseum capacity jump from 16,300 to 17,500. He also pushed a nearby 60-story tower, named the Great Lighthouse, with luxury condominiums and a five-star hotel. Some suburbanites opposed the tower, which was excluded from later renderings such as this. (Courtesy of the New York Islanders.)

When Charles Wang scrapped plans for the Great Lighthouse in 2005, he promised another centerpiece for the Mitchel Field redevelopment. Wang and his business partner, Scott Rechler, eventually proposed this H-shaped high rise to house a hotel and luxury residences. But the project, known as the Lighthouse at Long Island, continued to prompt resistance. Critics worried about effects on traffic congestion and ground water pollution. (Courtesy of the New York Islanders.)

Visitors skate in the proposed Celebration Plaza amid shops and restaurants in this rendering. Islanders logos and player pictures adorn a redesigned coliseum with new restrooms, larger seats, and expanded concourses. Architects also proposed a replacement roof to resemble a sail stretching over the arena. A promotional clip suggested the state-of-the-art venue might attract the NHL All-Star Game and college basketball tournaments. (Courtesy of the New York Islanders.)

A mock-up of the Lighthouse project's Entertainment District touts shops, a movie theater, and a sports complex. Charles Wang envisioned the complex as the Islanders' new practice facility, with four sheets of ice to attract regional and national tournaments. His plans also placed basketball courts and a health club in the complex, complementing a nearby minor league ballpark and a center for sports technology. (Courtesy of the New York Islanders.)

Proposing radical changes to the coliseum's facade and surroundings, this rendering places an outdoor café and landscaped park by the arena. Fountains shoot plumes of water near the coliseum, much as the venue's original architects envisioned three decades earlier. Like plans to build the venue, however, the redevelopment proposal met many obstacles. Nassau County approved Charles Wang to revive the area in 2006, but the Islanders owner soon became frustrated with local officials at the Town of Hempstead. As Wang emphasized the economic potential of the $3.8-billion project, town supervisor Kate Murray questioned how the Lighthouse would impact traffic and water. Wang announced in 2009 that he would explore relocating the Islanders. Should the coliseum lose its flagship tenant, the arena might become irrelevant—a potentially dreary conclusion to its storied history. (Courtesy of the New York Islanders.)

www.arcadiapublishing.com

Discover books about the town where you grew up, the cities where your friends and families live, the town where your parents met, or even that retirement spot you've been dreaming about. Our Web site provides history lovers with exclusive deals, advanced notification about new titles, e-mail alerts of author events, and much more.

Arcadia Publishing, the leading local history publisher in the United States, is committed to making history accessible and meaningful through publishing books that celebrate and preserve the heritage of America's people and places. Consistent with our mission to preserve history on a local level, this book was printed in South Carolina on American-made paper and manufactured entirely in the United States.

This book carries the accredited Forest Stewardship Council (FSC) label and is printed on 100 percent FSC-certified paper. Products carrying the FSC label are independently certified to assure consumers that they come from forests that are managed to meet the social, economic, and ecological needs of present and future generations.

FSC
Mixed Sources
Product group from well-managed
forests and other controlled sources

Cert no. SW-COC-001530
www.fsc.org
© 1996 Forest Stewardship Council

Find Your Place in History.